IMAGES of America
HISTORIC PETERSBURG

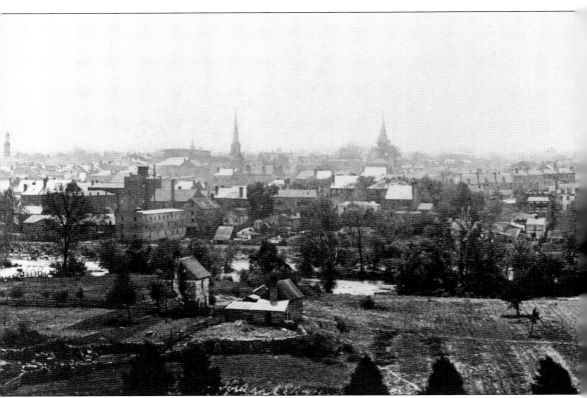

CITYSCAPE, 1866. This image of Old Towne Petersburg, taken shortly after the Civil War, reflects a city that is almost unchanged. The courthouse top and steeple of three churches are seen in the background. The foreground includes the ironworks, tobacco warehouse, and the trading post plus the homes of Grove Avenue. (Library of Congress.)

ON THE COVER: HOLIDAY INN, 1960. Interstate 95 was completed in 1958, ushering in a new era. Located between the North Carolina state line and Washington, DC, Petersburg had everything a traveler needed: industry, history, shopping, and tourism. This photograph was captured at the opening ceremony of the Holiday Inn, the first of multiple hotels on the exit. (Courtesy of the Southern Virginia Chamber of Commerce.)

IMAGES
of America

HISTORIC PETERSBURG

Laurel Charboneau

ARCADIA
PUBLISHING

Copyright © 2025 by Laurel Charboneau
ISBN 978-1-4671-6223-4

Published by Arcadia Publishing
Charleston, South Carolina

Printed in the United States of America

Library of Congress Control Number: 2025930340

For all general information, please contact Arcadia Publishing:
Telephone 843-853-2070
Fax 843-853-0044
E-mail sales@arcadiapublishing.com

Visit us on the Internet at www.arcadiapublishing.com

*To my husband, Wayne,
thank you for all the love and support.*

*To all the armchair historians and volunteers,
thank you for keeping Petersburg's history alive.*

CONTENTS

Acknowledgments		6
Introduction		7
1.	Blandford and Pocahontas	9
2.	Old Towne	19
3.	Pride's Field Commerce Street	47
4.	Folly's Castle	59
5.	Centre Hill	69
6.	Courthouse Historic District	75
7.	Poplar Lawn	87
8.	South Market and Atlantic Coast Line	99
9.	Halifax Triangle	109
10.	Walnut Hill	117

ACKNOWLEDGMENTS

A big thank-you to the Southern Virginia Regional Chamber of Commerce (SOVA COC), Jason from the Department of Historic Resources (DHR), the crew of Fire Station No. 2, Robin Beckwith, Wynne Churn, Ann Doviken, Walt Gaye, Mark Holt, Petey Kaens, Zanna Hickey, Hattie Moore, Dwayne Nelms, Alan Sims, Von Parr ish, Lynda White, Wayne "Bob" Van Fossen, Anthony Carpenter, and anyone else in the community who shared their personal photographs and stories with me. I would also like to thank collection manager Mike Cormier for being the only paid employee of Petersburg's closed museums who supported this project.

INTRODUCTION

In 1622, a group of English explorers discovered an area of the Appomattox River perfect for a settlement. Fort Henry was established in 1646 and became a frontier boundary. Exploration to the west left from this point and it was one of the few places where Native Americans could freely trade with the settlers. This was followed by a trading post, the only bridge spanning the Appomattox River for 30 miles, and a deepwater harbor. This harbor led directly to the Atlantic Ocean. In the early 1700s, a tobacco warehouse was built, followed by mills and stores. The town was named Petersburg. The settlements of Pocahontas and Blandford were soon incorporated into the town, and by 1784, a city was born. The harbor became the second largest in the Virginia colony. Petersburg was a depot for all imported supplies going south. This city was known for selling the finest imported goods. A Revolutionary War battle occurred here, followed by a visit from George Washington.

The first line of railroad tracks leading into North Carolina was laid in 1830, making the city the largest transportation hub in the state. The population exploded and included a free African American community. Petersburg had cotton and textile producers, corn and flour mills, iron and brass foundries, multiple potters, and a silversmith plus peanut and tobacco warehouses along with numerous shops and restaurants. In the middle of that century, Petersburg had gaslights, a waterworks, and a telegraph office. Doing business in this city was a true pleasure. This city was so important that the longest siege on American soil happened here during the Civil War. After the Union victory, the city rebounded. A member of one of the ladies' groups was witnessed participating in a new tradition that is said to have inspired a national holiday.

The 1900s started with two steamboats connecting with ports in Richmond and Norfolk plus three railroads and electricity. By 1910, this city was the principal manufacturer of Spanish peanuts, tobacco, and travel trunks in the country in addition to being prominent in the production of cornmeal, fabrics, fertilizer, and wine. It was such a leader that the 1939 World's Fair highlighted three of Petersburg's industries and three historic sites in the Virginia pavilion and was a part of "The World of Tomorrow." All these businesses were supported by people who lived and worked in the city. Every neighborhood had houses, gas stations, stores, and restaurants. There were six fire departments. The midcentury had this city heading in a positive direction. The tobacco giant Brown and Williamson was expanding. A new hospital had been constructed, and old homes and buildings were torn down to make room for sleek new office buildings and warehouses. The interstate highway was completed in 1958, bringing more growth and tourism. This city was so sure of itself that updates to the transportation corridors were unheard of.

Many consider Petersburg to be the blueprint of the civil rights movement. Described by Dr. Martin Luther King Jr. to be one of the most segregated cities he had ever been to. In 1960, church leaders, members of the community, and students organized the first library sit-in in America, which was followed by a summer of marches. Petersburg was one of the first cities in Virginia to desegregate its public buildings in 1960 and the first to celebrate the MLK holiday.

There have been some serious economic downturns since the 1970s, which include the loss of every major industry and employer. Petersburg has not just embraced this despair but has been able to cultivate a reputation all its own, one that has resulted in something remarkably interesting. It is one of the few places where growth patterns from the 1600s are still visible. The original grid and roads are still in place. That has resulted in the largest concentration of 18th-, 19th-, and 20th-century commercial and residential buildings in America. There are 12 districts and over 30 individual structures listed in the National Register of Historic Places and 44 structures listed on the Virginia Landmarks Register. To have this designation, something important must have happened. These areas are in such proximity to each other that a person has to wonder what happened to make one street different from the next.

That is the question that *Historic Petersburg* answers. It gives a visual definition of the importance of each district. Blandford and its cemetery complex are just one of many historic churches in the city. Pocahontas Island is a community that embraced the freedom of the enslaved prior to the Civil War. Old Towne has industrial and residential structures dating back to the 1700s. Battersea-Pride's Field had a canal and a baseball field. The homes of the city founders are still standing in Centre Hill and Folly's Castle. Multiple banks, stores, and a post office with original interiors can be found in the Courthouse Financial District. A few remaining palatial mansions of industrial leaders are left on South Market Street. Poplar Lawn has ties to the super-wealthy, the Civil War, and the civil rights movement. During the Jim Crow era, African Americans thrived in the Halifax Triangle which also boasts three churches with congregations almost 200 years old. The Atlantic Coast Line Railroad (ACL) district is centered around a railyard and a mid-20th-century tobacco production complex, with the luggage and optical industry in the Commerce Street Industrial area. Walnut Hill is the newest addition to the historic register, being a Civil War battleground turned into a historically accurate representation of Americana.

Using images and information provided by the Virginia Department of Historic Resources, libraries, universities, city directories, and members of the community, Laurel Charboneau has been able to interpret the story of each of Petersburg's historic districts in a memorable way. Most properties listed in this book are privately owned and are not open to the public. All are visible from the public right-of-way. Please be respectful of owner privacy.

One

BLANDFORD AND POCAHONTAS

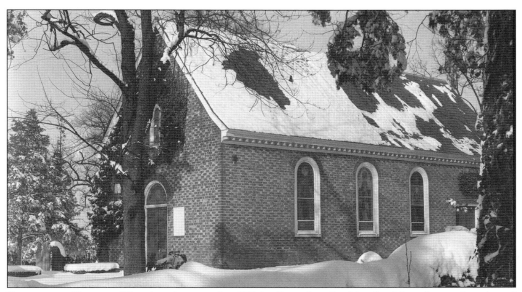

BLANDFORD CHURCH. The church erected in 1734 is Petersburg's oldest building. It was abandoned in c. 1806 and sat crumbling to dust until the Civil War when it was used as both a telegraph station and field hospital. In 1866, the Ladies Memorial Association began to preserve the structure. Between the years 1904 and 1912 fifteen Tiffany windows were installed. In 1939, the church was featured in the World's Fair as one of Petersburg's many historical sites. (Library of Congress.)

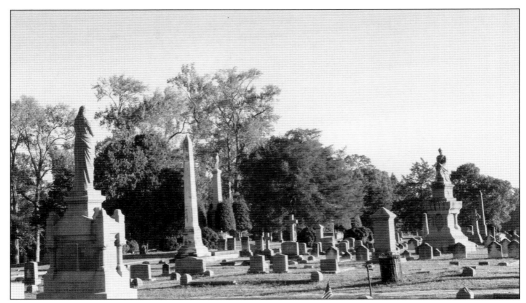

BLANDFORD CEMETERY. The graveyard surrounding Blandford Church is one of the oldest, largest, and historically significant cemeteries in the state. It is the final resting place of citizens and veterans of every military war, including a mass grave containing the remains of 30,000 Confederate soldiers. (Courtesy of L. Charboneau.)

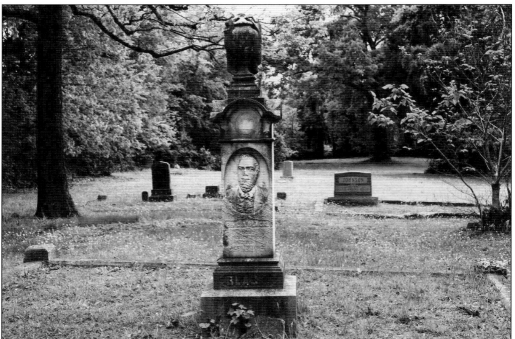

PEOPLE'S CEMETERY. Edith and William Williams deeded one acre of land across from Blandford Cemetery in 1840 to 28 prominent freemen; in 1865, an additional two acres were added, and an additional five and one eighth acre lot was deeded in 1870. Undertaker Thomas Brown was the owner of the entire property in 1920. He organized the Colored Cemetery Association. (Courtesy of L. Charboneau.)

WELCOME TO BLANDFORD. The settlement of Blandford was established in 1700. Growing to be an essential business community, it was annexed into Petersburg in 1784. The double house is a style seen in almost every Petersburg neighborhood. This 1938 photograph was taken on present-day Wills Street. (Library of Congress.)

BLANDFORD VOCATIONAL TRAINING SCHOOL. The property at 812 East Bank Street was a vocational school teaching African Americans skills like construction, homemaking, and farming. (Courtesy of Jackson Davis Collection, Albert & Shirley Small Special Collections Library, University of Virginia.)

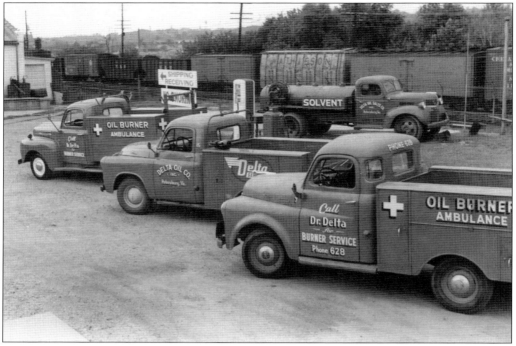

FUEL YARD. Delta Oil on Bollingbrook Street has provided the city with fuel for 125 years. It is an integral part of Petersburg's history. (Courtesy of Delta Oil Historic Archives.)

WTVR TV. Scheduled for completion in 1971, this station was not built in the advertised spot. It was located on Crater Road across from People's Cemetery, where it broadcast until the station moved in 1993. Now it is a group home. (Courtesy of the Southern Virginia Chamber of Commerce.)

HARBOR. In 1730, a small wharf was created on the banks of the Appomattox River between the settlement of Pocahontas and Petersburg. This became a deepwater harbor. For the next 200 years, this area was a major trade center. This 1889 advertisement is for Old Dominion steamship lines. The cost for a roundtrip ticket from Petersburg to New York was $20. (Courtesy of Petersburg City Directory.)

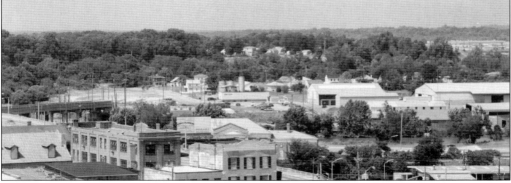

POCAHONTAS ISLAND, 1958. In 1749, the land on the wharf had been divided into 67.5-acre lots. The town was called Pocahontas. The original grid is still in place, and the lots are still the same. The road names have changed. Pocahontas Street was Main, Whitten was South, Rolfe was Third, and Logan was a cross-street called North South. (Courtesy of the Southern Virginia Chamber of Commerce.)

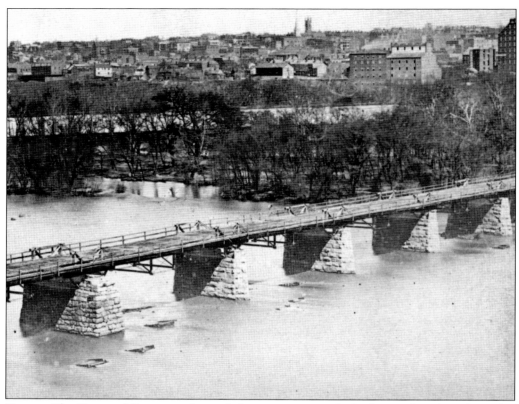

BRIDGE. The House of Burgess authorized the construction of a bridge not less than thirty feet wide, ten feet above the water, with three-foot rails in 1759. This was the only bridge that crossed the Appomattox for 30 miles, making Pocahontas an important trade town. Destroyed and rebuilt after the American Revolutionary War, Civil War, floods, and a tornado, this bridge has been essential to Petersburg for centuries. (Library of Congress.)

JARRATT HOUSE. John Wilder built a double house on 810 Logan Street to be used as a rental property in 1820. It was sold to Lavina Sampson, a Native American, in 1853. She sold the home in 1877. This house was owned by the Jarratt family from 1877 until 1991. (Courtesy of L. Charboneau.)

215 Whitten Street. The property at 215 Whitten Street has been called the Underground Railroad House since the 1800s. Tax records from 1820 show five Black landowners on Pocahontas Street. In 1851, the island had a new train station, a bustling harbor, and was avoided by White people. It is more than probable that this area was a stop on the Underground Railroad. The 1860 census documented 30 Black and 16 mixed-race landowners. It was a thriving community. The Underground Railroad House is a rare example of an 1800s freeman's home, complete with an outhouse and outdoor baker oven. (Courtesy of L. Charboneau.)

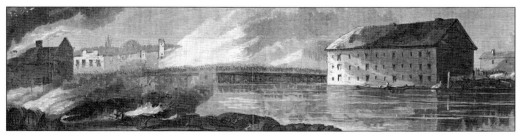

Civil War. During the Civil War, goods were still being transported through Pocahontas Depot; in April 1865, the bridge was one of the evacuation routes used by Confederate troops. (*Harper's Weekly*, 1865.)

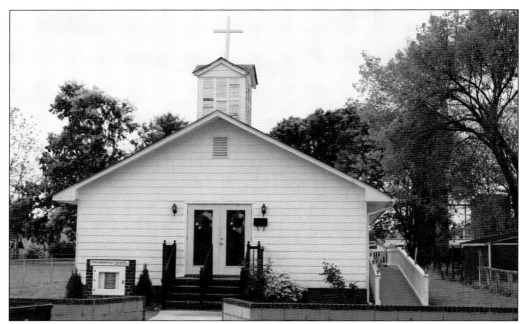

POCAHONTAS CHAPEL. Established in 1800, the Pocahontas Chapel was used as both a place of worship and a school. It was General Grant's headquarters during the Civil War. In 1866, the New York Freedman's Relief Society constructed a new chapel that was destroyed by an F4 tornado in 1993. That chapel has been rebuilt. (Courtesy of L. Charboneau.)

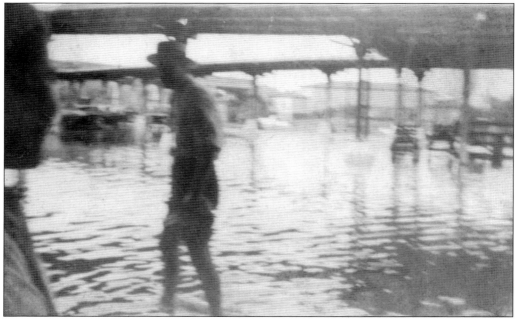

FLOOD. In 1910, the area was devastated by a flood destroying the bridge. To keep this from happening again, in 1915, the Army Corps of Engineers built a diversion channel that turned Pocahontas into an island. During World War I, a neighboring town began producing chemicals, and many residents moved to be closer to the new job opportunities. This image shows the bridge in the background after a 1940 flood. (Courtesy of Hattie Moore.)

224 Whitten Street. Richard Stewart was the honorary mayor of Pocahontas Island. He dedicated his retirement to preserving and sharing the history of the oldest African American community in the United States. If it were not for him, the unique history of Pocahontas Island would have been lost. This was the site of the Pocahontas Island Black History Museum. It housed a complete history of this community and a collection Stewart had personally acquired and curated. (Courtesy of L. Charboneau.)

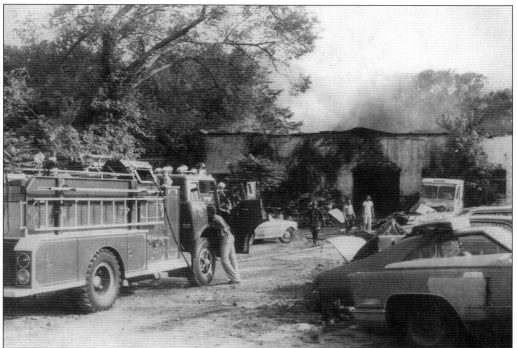

Scotts Auto Parts. The parts yard on 134 Rolfe Street was well known to all the local mechanics. (Courtesy of Fire Station No. 2.)

ROPER LUMBER. Opened in 1915, Roper Lumber was a major employer. Almost every home in Petersburg was constructed using wood supplied by them. This advertisement appeared in the 1963 city directory. The family-owned business closed in 2010. (Courtesy of Petersburg City Directory.)

RICHARD WINE DISTILLERY. Opened on Haxhall Street in 1955, this company produced many brands of sweet wines, including Wild Irish Rose. The company left Petersburg in 1993. Pocahontas Island was designated to both the Virginia Landmarks Register and the National Register of Historic Places in 2006. Since 2015, it has been on the most endangered historic neighborhoods in Virginia list. (Courtesy of L. Charboneau.)

Two

Old Towne

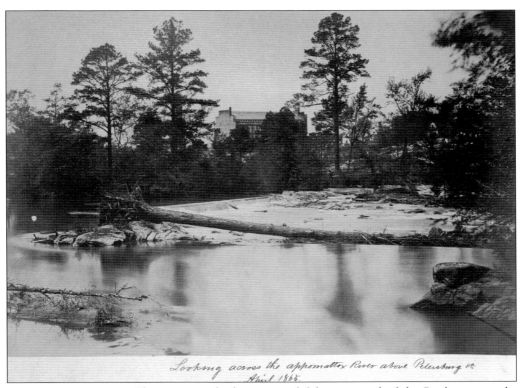

FALLS AT APPOMATTOX. This area was the hunting and fishing ground of the Powhatan people. In the 1600s, the English settled here. The strong currents of the Appomattox were perfect for powering mills. The only bridge for 30 miles was built, followed by a shipping harbor. The Old Towne, Prides Field, and Pocahontas Island Historic Districts are located on the river's banks. (Library of Congress.)

PETER JONES TRADING COMPANY. In 1644, Fort Henry was established; for 30 years, it was used as a frontier boundary and one of the few places where Native Americans could trade with the settlers. In 1675, Peter Jones opened a trading company near the entrance to the fort. The area became known as Peter's Point. Part of this building is still standing on Old Street. (Library of Congress.)

OLD STONE HOUSE. Also known as "the old stone house," 548 Plum Street is one of Petersburg's oldest homes. This structure has survived fires, war, and an F4 tornado. (Courtesy of the Virginia Department of Historic Resources.)

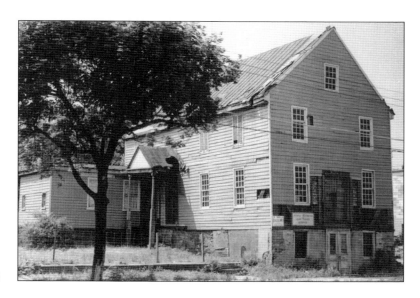

THE JOHN BAIRD HOUSE. John Baird was one of Petersburg's earliest real estate developers. After the American Revolution, he owned one-quarter of present-day Grove Avenue. The property at 420 Grove was the original building lot 31. (Courtesy of the Virginia Department of Historic Resources.)

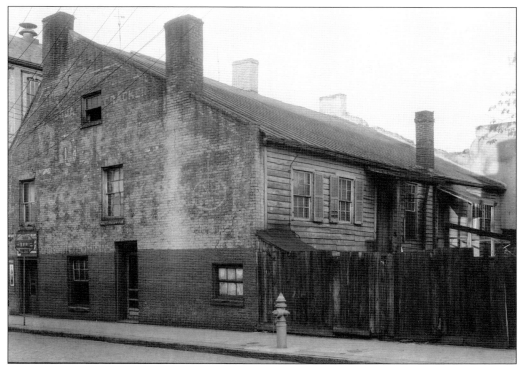

GOLDEN BALL TAVERN. The tavern stood at the corner of present-day Grove Avenue and Market Street. Built in 1764, this was used as a courthouse, inn, and meetinghouse. It was General Cornwallis's Revolutionary War headquarters. A banquet was held here for George Washington during his visit on April 4, 1791. It housed multiple businesses until it was torn down in 1944. (Library of Congress.)

CROSS AND PLUM. The settlement grew into a town. In 1797, the city had 300 homes, businesses that were flourishing, and about a million dollars in trade exports per year; the population was around 2,800. This photograph is the corner of Cross Street and Plum Street in the late 1800s. (Library of Congress.)

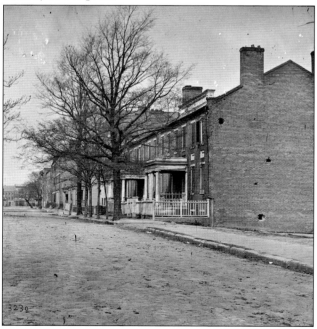

BOLLINGBROOK STREET, 1865. Col. Robert Bolling built the first tobacco warehouse on the banks of the Appomattox River in 1730, followed by homes, mills, and stores. Bollingbrook Street was the main road leading into Petersburg and one of the first roads paved in 1813. This street has been home to a mixture of business and residential properties for almost 300 years. (Library of Congress.)

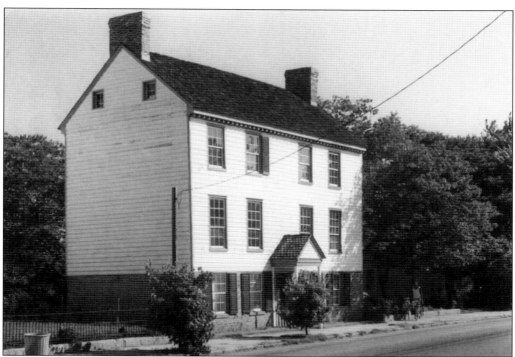

BOARDINGHOUSE FOR YOUNG LADIES. In 1824, Elizabeth Ann Somervill placed an ad in the local paper informing everyone that she was opening her house on 23 High Street to young ladies. For $4 a month, they could attend the best seminaries, learn piano, and become polished members of society. (Courtesy of the Virginia Department of Historic Resources.)

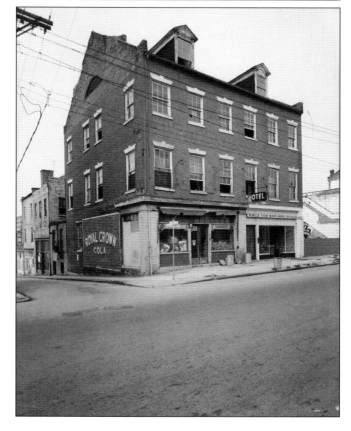

NATHANIEL FRIEND HOUSE. When volunteers were needed to fight in the War of 1812 merchant Nathaniel Friend was chairman at the meeting that raised the funds to support the effort. His two-story Federal-style home on Bollingbrook Street was built in 1815. (Library of Congress.)

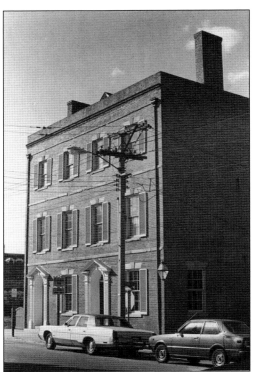

FARMERS' BANK. The Farmers' Bank on Bollingbrook opened in 1811, the great fire happened in 1815, and every building in the city was destroyed. Rebuilding out of bricks was completed by 1817. The bank was authorized to issue its own circulatory notes. During the Civil War, those notes were Confederate. The Farmers' Bank was out of business in 1865. (Courtesy of the Virginia Department of Historic Resources.)

APPOMATTOX IRON WORKS. Between 1810 and 1825, an iron foundry was built. The original location was 33 Old Street. It moved across the street in 1896. It was in operation as a foundry until 1946, a machine shop until 1952, and a mill and supply store until 1972. Currently, it is an apartment building. (Library of Congress.)

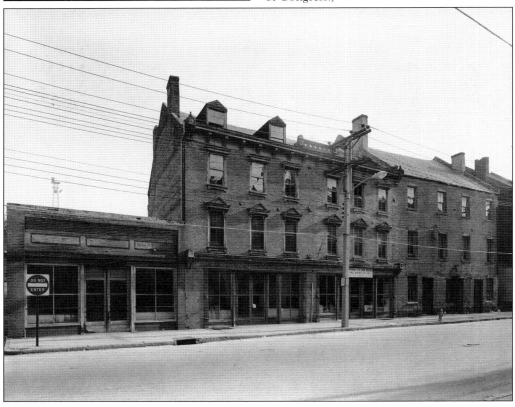

The Trapezium House. Charles O'Hare was one of our most colorful residents. He gained his wealth working for the Dutch East India Company. In 1817, he built his home with no right angles. He had a pet rat, numbered the wood in his shed, and chased children with a stick. Now a private residence, this photograph was taken in 1930. (Library of Congress.)

Rowhomes, High Street. High Street was becoming the most desirable street in town. The townhomes or rowhouses were built in the 1870s. Pictured are Smith's Row, built in the Federal style and named after the original landowner, and May's Row, constructed in the Italianate style, which is named after the builder. Local artist William Simpson Jr. lived at No. 2. The sketches and watercolor images created by him and his father are accurate representations of Petersburg from 1816 to 1895. (Library of Congress.)

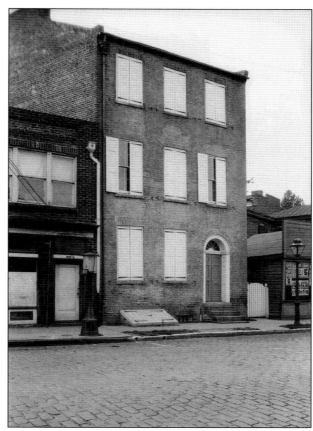

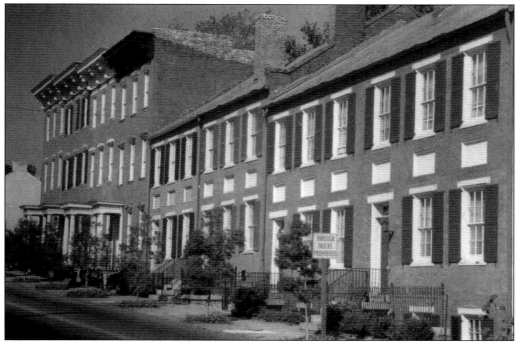

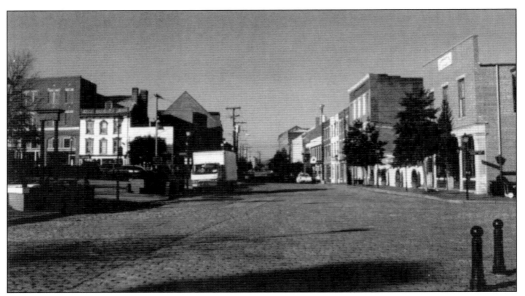

CORNER OF SYCAMORE AND OLD. In 1800, the city had eight hundred homes, six tobacco factories, six flour mills, two potteries, and an iron and brass foundry. Sycamore had numerous shops that sold the finest European goods. This corner has been a shopping area for over 200 years. The white building on the left was the Petersburg Fruit House, opened by Filippo Deluca in 1915. He and his family lived above their shop for over 100 years. (Courtesy of the Virginia Department of Historic Resources.)

RAILYARD. The railroad came to Petersburg in 1830 with the first line of tracks leading into North Carolina. This made the city the largest transportation hub in the state. (Courtesy of the Virginia Department of Historic Resources.)

The Exchange Building. Petersburg's main exports were cotton, tobacco, and wool. In 1841, the exchange was built in the high Greek architectural style to control trade with the crops being sold auction style to the highest bidder. In March 1960, eleven African Americans were arrested for protesting segregation. The exchange was the courthouse where their case was heard. It has served as a museum since 1978. (Library of Congress.)

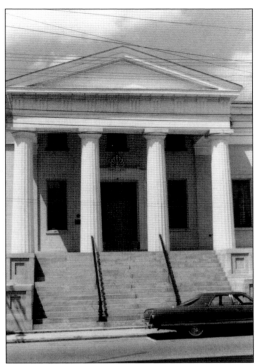

Hiram Haines Tavern. Hiram Haines was a local magazine editor and tavern owner. His wife, Mary Ann Philpotts, was a childhood friend of Edgar Allan Poe. After Poe married his 13-year-old cousin Virginia Clemm in 1835, they spent their two-week honeymoon at this tavern on 12 Bank Street. (Courtesy of the Virginia Department of Historic Resources.)

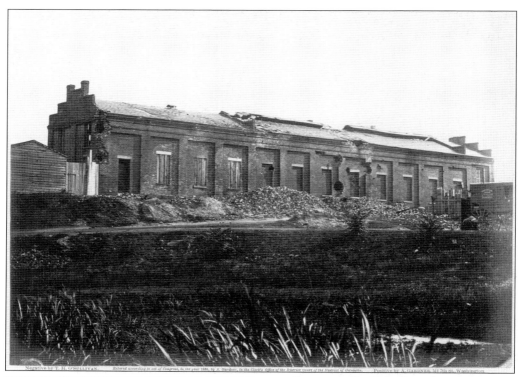

GASWORKS. In 1841, Petersburg got gas. The gasworks were on Bollingbrook Street and enlarged in 1848; most businesses, streets, and homes of the wealthy now had lights. This photograph taken after the Civil War by Alexander Gardner shows damage to the smokestacks. (Library of Congress.)

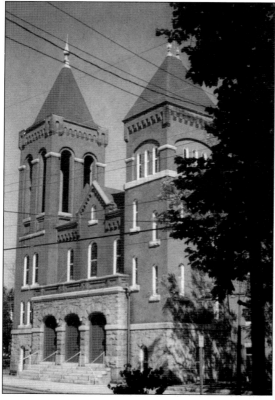

METHODIST CHURCH, 615 HIGH STREET. An impressive neighborhood needs a church to match. This Methodist church designed in 1847 in a Gothic Greek revival style, was used as a temporary cemetery during the Civil War. It was remodeled as Romanesque Revival in 1897. Serving the neighborhood for over 100 years, it was closed and sold in the 1980s. (Courtesy of the Virginia Department of Historic Resources.)

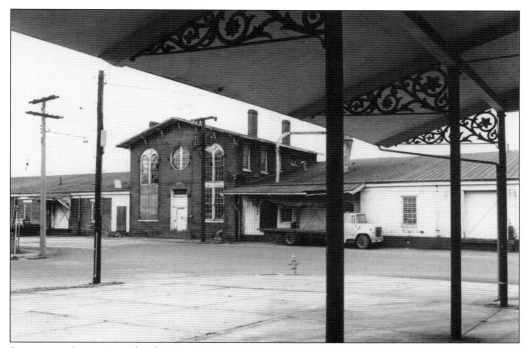

SOUTHSIDE DEPOT. Southside Depot was constructed in 1864. This is the oldest extant rail station in Virginia. It has survived the Civil War, numerous floods, and a tornado. (Courtesy of the Virginia Department of Historic Resources.)

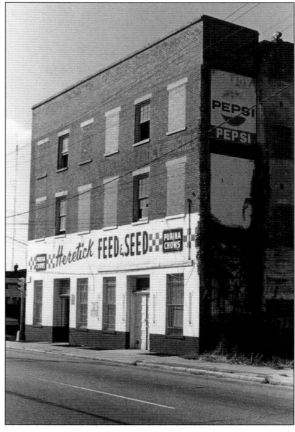

HERETICK FEED & SEED. The Civil War started in 1861. There were no hospitals in the city, but by the end of that year, there were seven. The Ladies Confederate Memorial Hospital was on the corner of Bollingbrook and Third Streets from 1861 until 1865. The building has housed Heretick Feed & Seed since 1945. (Courtesy of the Virginia Department of Historic Resources.)

312 High Street. During the war, military officials used people's houses as their own. This house at 312 High Street was Robert E. Lee's second headquarters. (Courtesy of the Virginia Department of Historic Resources.)

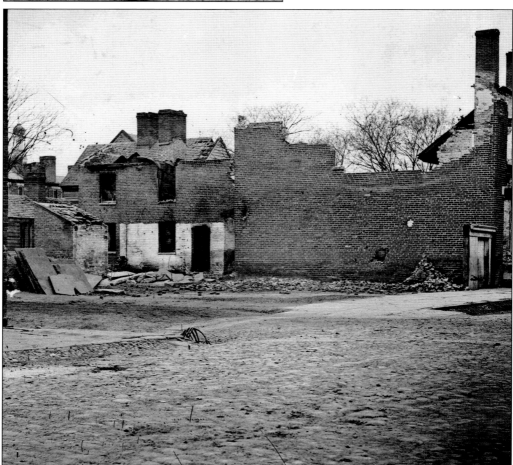

Civil War. On June 9, 1864, Petersburg was under siege by Union troops. The gasworks, harbor, and railroad yard were in Olde Towne making it a defense point. Life for residents was horrific. Kids were begging soldiers for scraps, and people were eating mice, mules, pigeons, and rats. Every structure suffered damage. This is Bank Street in 1865; note the courthouse top in the background. (Library of Congress.)

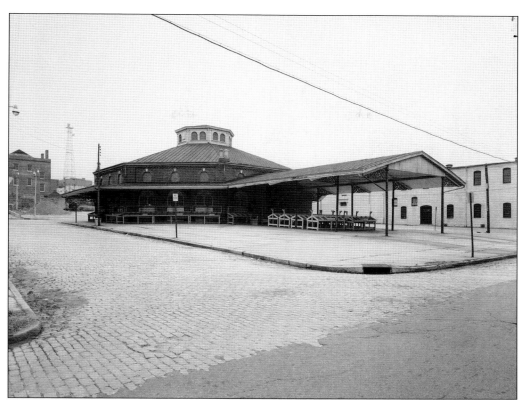

Farmers Market. In 1879, the city or farmers market was established to allow free trade of goods. Perishables were sold indoors, and produce stalls were located outside. Its unique shape makes it one of the most recognizable buildings in Virginia. It has appeared in numerous movies and television shows. (Courtesy of the Virginia Department of Historic Resources.)

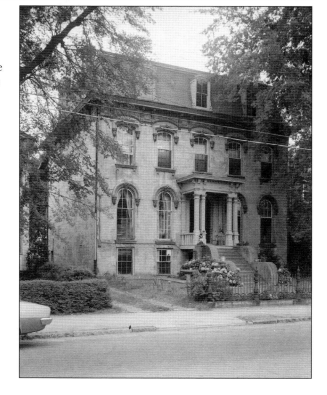

410 High Street. John Jackson was a tobacco merchant. In 1868, he and his wife, Anne, built this Italianate mansion to rival the other homes on the street. (Courtesy of the Virginia Department of Historic Resources.)

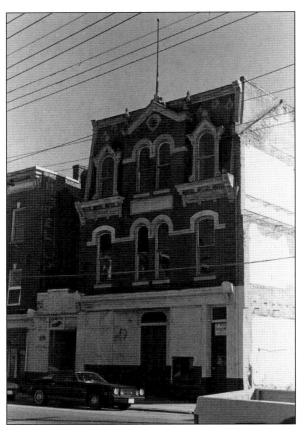

18 Bollingbrook Street. Julius Liebert was a bottler of root beer, sarsaparilla, and Bergner & Engel's lager beer. In 1884, he moved his bar, billiard hall, and German beer garden restaurant to this newly built Second Empire–style building. (Courtesy of the Virginia Department of Historic Resources.)

321 Grove Avenue. This 1870 brick mansion may not be the oldest, but it is the most imposing home on Grove Avenue. The 1876 owner was Harry Heineman, proprietor of Heineman's Saloon on Bank Street. The saloon also sold cigars, served lunch, and offered oysters in season. (Courtesy of the Virginia Department of Historic Resources.)

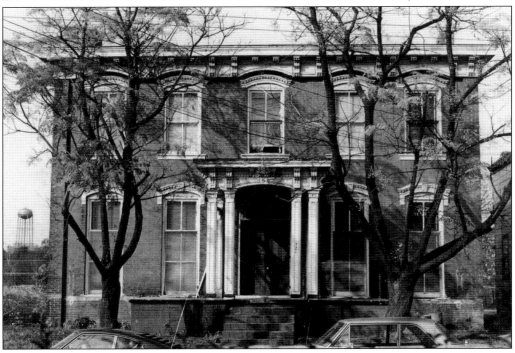

411 Hurt Street. Not everyone was wealthy. A stark difference to the homes on Bollingbrook Street, Grove Avenue, and High Street are just a block away. This clapboard double house on Hurt is a typical turn-of-the-century tenement or worker's house. (Library of Congress.)

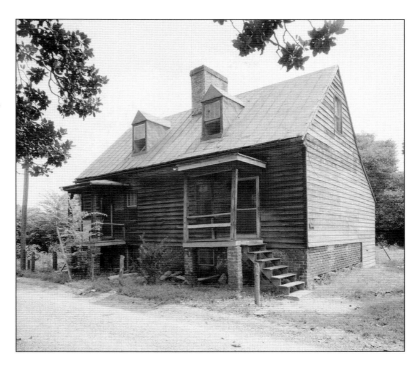

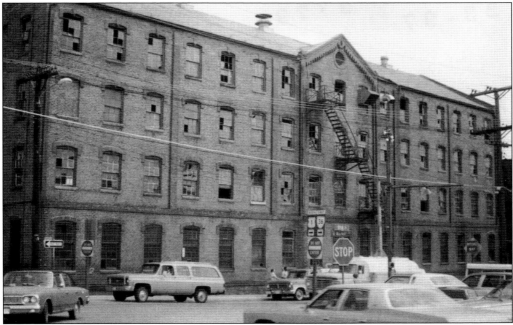

127 Old Street. The Dunlop family began manufacturing tobacco in the 1820s. In 1887, David Dunlop opened his tobacco company, which became the largest exporter of plug and twist tobacco in America. He died in 1902, and the following year, his son began leasing the building to British American Tobacco. Purchased by Maclin-Zimmer-McGill tobacco in 1945, this warehouse was in use until 1968; in 1976, it was converted into the Carriage House apartments. (Courtesy of the Virginia Department of Historic Resources.)

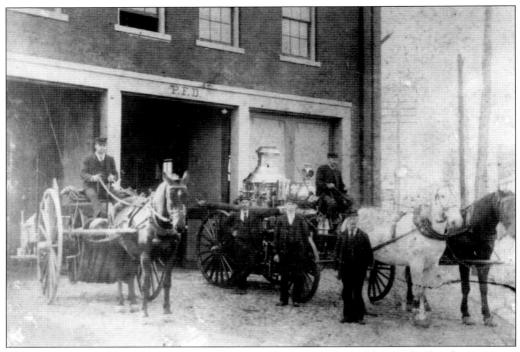

Fire House No. 1. The fire department was established in 1773. It is one of the first fire departments established in America. This 1890s photograph was taken in front of Fire House No. 1 on Bank Street. (Courtesy of Fire Station 2.)

423 Third Street. In 1879, this was the location of Crystal Ice Co. In 1900, it was J.B. Worth Ice Co. The company became Blower Ice in 1940. This 1974 photograph shows it when it was called City Ice. (Courtesy of the Virginia Department of Historic Resources.)

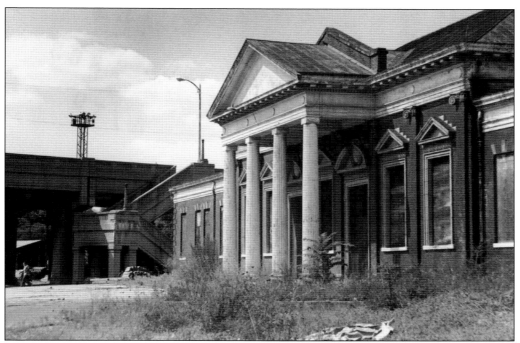

UNION STATION. The Norfolk & Western and the Atlantic Coast Line Railroads built this passenger station in 1909. Both railroads ran from north to south. This station was in use until 1977. (Courtesy of the Virginia Department of Historic Resources.)

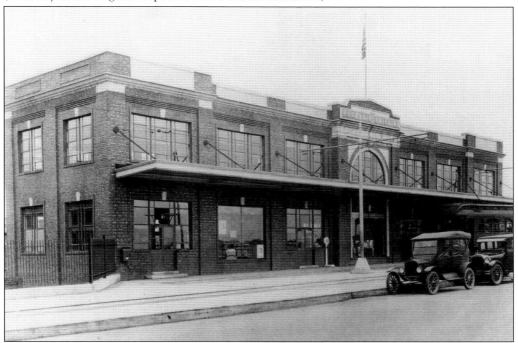

ELECTRIC COMPANY. The building next to the MLK Bridge was the original Electric Company. Opened in the late 1800s, by 1910, this station was generating 6,000 horsepower—enough to light the city. (Courtesy of the Virginia Department of Historic Resources.)

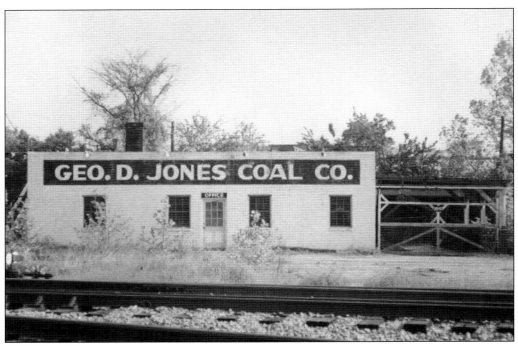

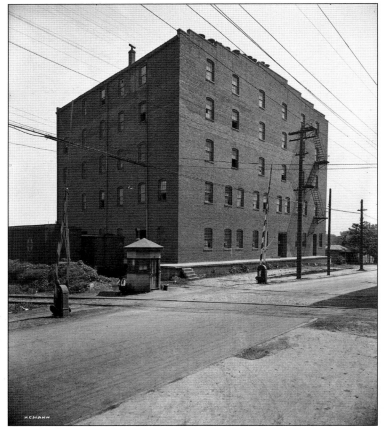

GEORGE JONES COAL. George Jones Coal was located on River Street. The company supplied coal and oil to residents from 1890 until 1982. (Courtesy of the Virginia Department of Historic Resources.)

DIXIE PEANUT, 1915. Peanuts were a dominant industry from the mid-1800s until the early 1920s. Dixie was at 321 East Bank Street, one of numerous peanut processors. (Courtesy of Library of Virginia.)

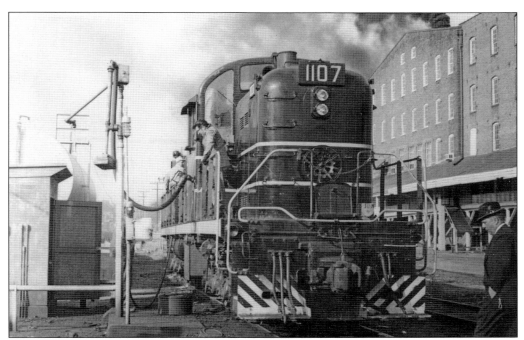

SEWARD LUGGAGE. The Seward Luggage Company opened in 1878. This company had production plants all over the city and was the world's largest manufacturer of footlockers and trunks. In 1907, the company built a new factory on High Street, changing it from an upper-class to a working-class neighborhood. After World War II, they began making furniture. This picture is of the train fueling area, located on Lafayette Street behind the factory. (Courtesy of Walt Gaye.)

315 NORTH SYCAMORE STREET. Stewart Liquor Company was "the House of Quality" selling liquors of all kinds in 1917. This picture was taken by photographer C.R. Rees (Courtesy of Albert & Shirley Small Special Collections Library, University of Virginia.)

CORNER OF BANK AND NORTH SYCAMORE STREETS. The Truelove Liquor Company was at 309 North Sycamore. The Jefferson Liquor Company was next door, and both specialized in mail-order sales. Across the street was Sol Coopers Department Store, purveyors of the finest furnishings and household goods. (Courtesy of Albert & Shirley Small Special Collections Library, University of Virginia.)

CENTURY THEATRE. Burlesque, vaudeville, and moving pictures all happened at 249 North Sycamore Street. The Century opened in 1920 and closed in the early 1970s. (Courtesy of Library of Virginia.)

THE ARK. Opened in 1920, this Art Deco–style department store was a favorite among locals. This picture taken in 1974 shows the first floor was modernized with block-glass windows. (Courtesy of the Virginia Department of Historic Resources.)

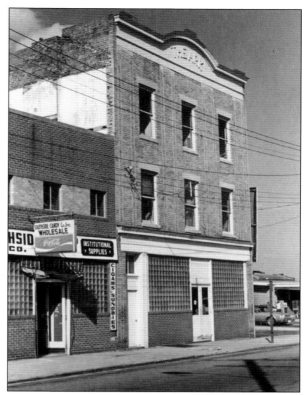

MARATHON GAS. This photograph taken around 1928 is of the intersection of Second and Bank Streets. (Courtesy of Delta Oil Historic Archives.)

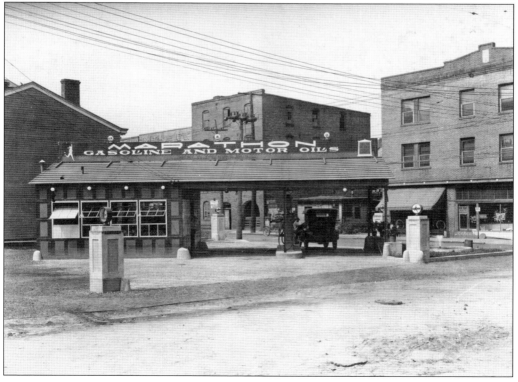

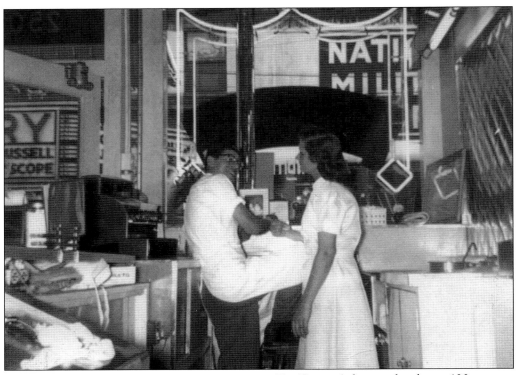

THE DIXIE. A favorite for almost 100 years, The Dixie has been serving breakfast and lunch at 317 North Sycamore Street since 1939. This is Louis Plakas and Patricia Childress in 1955. (Courtesy of The Dixie.)

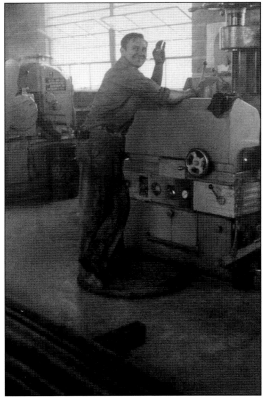

JOHN ORTON, 1956. John Orton was a machinist at the E.E. Titus Machine Shop and Foundry on South Street, which was open from 1910 until 1975. Examples of the shop's work can still be seen on utility hole covers around the city. (Courtesy of Ann Dovekin.)

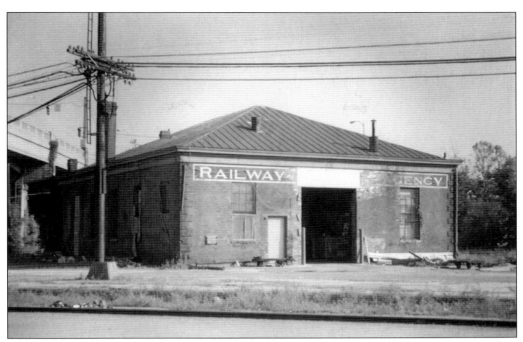

RAILWAY EXPRESS TERMINAL. This company was a package delivery service with a small terminal on the corner of River and Second Streets. It survived a devastating flood in 1942 but was demolished by an F4 tornado in 1993. (Courtesy of the Virginia Department of Historic Resources.)

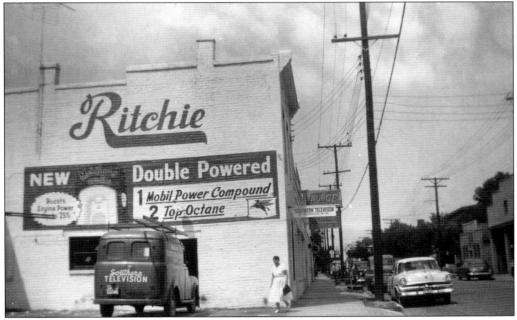

RITCHIE. This vibrant shopping area was the corner of North Market Street and Grove Avenue in 1956. The address of Ritchie Hardware was 212-214 Grove Avenue. Opened in 1946, the store supplied everything a homeowner needed until it caught fire in 1980. The blaze also destroyed the neighboring Peter Jones Trading Company. (Courtesy of Delta Oil Historic Archives.)

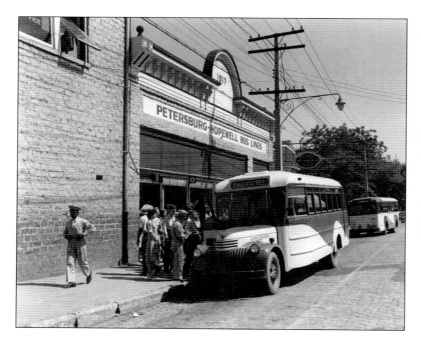

BUS STATION, 1942. The bus replaced the electric trolley, with more efficient stops around the Tri-Cities. The route ran from Camp Lee, Colonial Heights, Hopewell, and Petersburg. This station was located at 28 East Bank Street. (Courtesy of Library of Virginia.)

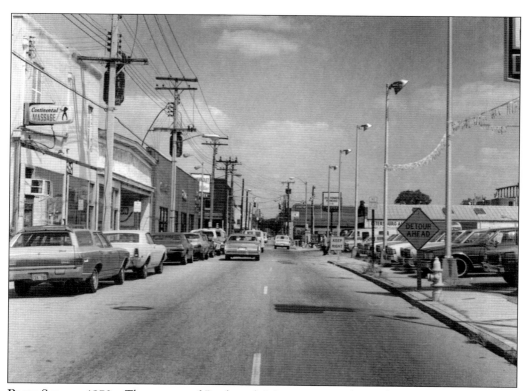

BANK STREET, 1970s. The corner of Bank and Adams was one busy place. There were two car dealerships, a bar, a massage parlor, and rent-by-the-hour rooms—everything that Petersburg was once known for. (Courtesy of the Virginia Department of Historic Resources.)

S.A. & A. Wrecking Co. The late 1960s brought change. When an old mansion or warehouse needed to go, S.A. & A. was the one to call. (Courtesy of the Southern Virginia Chamber of Commerce.)

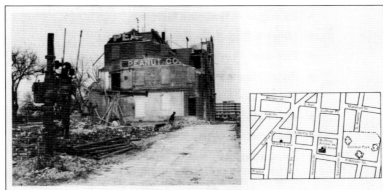

S. A. & A. WRECKING CO.

Demolition specialists, we have a veritable potpourri of goods that have been salvaged from demolished buildings, steel towers, and tanks. We have used building materials of all kinds including steel beams and old brick, plus tools, Christmas decorations, and used appliances. Our crew is fully insured and offers fast, efficient, and economical service.

222 Maple Lane, Petersburg Phone 732-3054

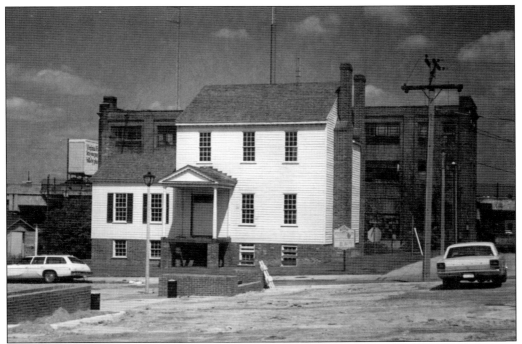

McIlwaine House. Erasmus Gill was a town founder, and his home was built in 1794. George H. Jones was mayor and owner of this house from 1815 to 1816. Archibald Graham McIlwaine, an industrial leader, bought the home in 1838, and his family lived in it until 1971. The original location was present-day Wythe Street. This is one of Petersburg's most significant homes, with woodwork that is recognized by the Smithsonian. Spared from destruction, it was moved to Cockade Alley in 1971. (Library of Congress.)

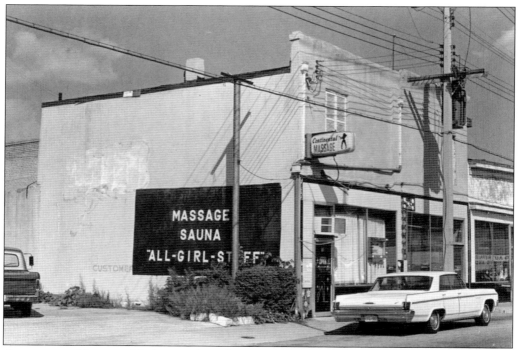

CONTINENTAL MASSAGE. Machine and warehouse work was hard on the body. The staff at 19 Bank Street rubbed away the pain and soothed sore muscles from 1974 until 1981. (Courtesy of the Virginia Department of Historic Resources.)

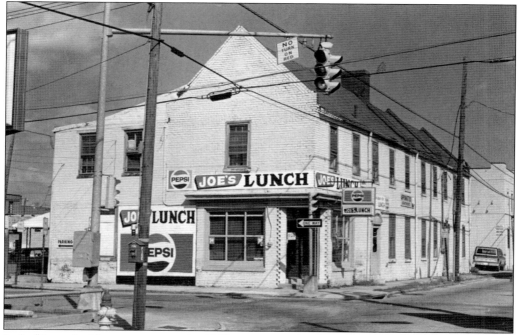

JOE'S. "Eat at Joe's" was a saying in the 1940s cartoons. This spot for a quick breakfast or lunch fed the shift workers for years. Joe's was located across the street from the Mayton Transfer Storage and multiple machine shops. (Courtesy of the Virginia Department of Historic Resources.)

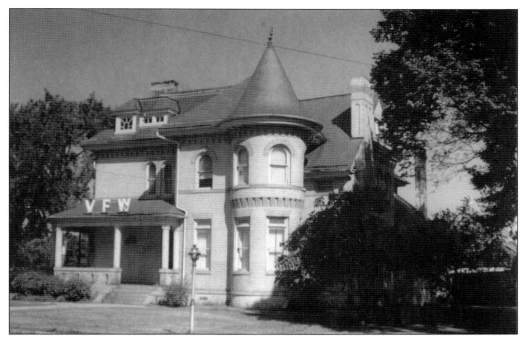

VFW. The property at 405 High Street was built in 1891 by J.A. Gill, proprietor of Gill and Bros wholesale grocer. From the 1930s until 1970, this was the Wells Funeral Home. Throughout the 1970s, the Veterans of Foreign Wars, the oldest veterans' service organization in the United States, used this house as its headquarters. It then became the High Street Inn; Katherine Hepburn slept here in 1986. This is now a private residence. (Courtesy of the Virginia Department of Historic Resources.)

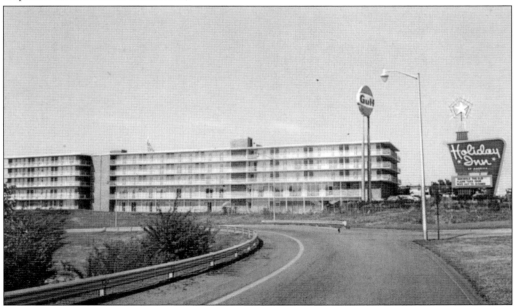

HOLIDAY INN. The Holiday Inn opened in 1960 and was one of many new chain hotels opening that year. It was modern in more than its sleek streamlined design, it had 165 rooms, offered free TV, and had air conditioning in every room. (Courtesy of R Gold.)

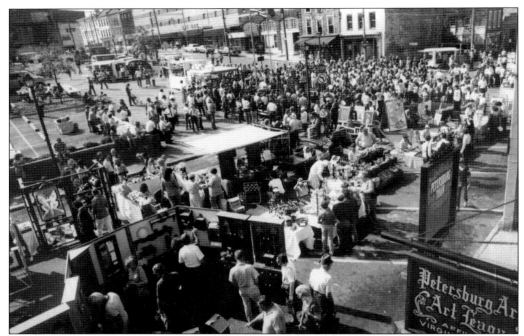

NOSTALGIA FEST, 1976. The intersection of Old and Sycamore has been known for supporting local artisans for centuries. Nostalgia Fest was just one of many events that took place at this location. (Courtesy of the Virginia Department of Historic Resources.)

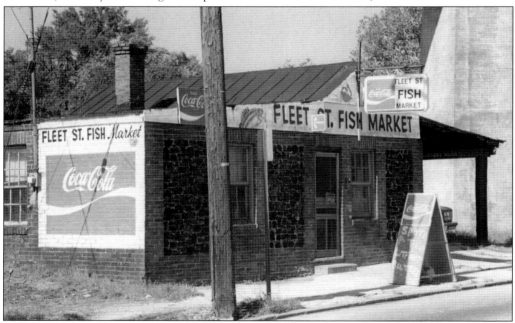

FLEET STREET FISH MARKET. Old Towne ends on Fleet Street. A favorite local fishing area is nearby. The fish market cleaned the fish caught at the river and made sure that there was never one that got away. The Old Towne Historic District was put into the National Register of Historic Places in 1980, with boundary increases in 2008 and 2012. (Courtesy of the Virginia Department of Historic Resources.)

Three
Pride's Field Commerce Street

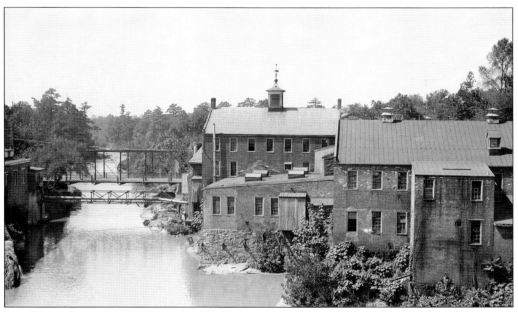

The Upper Appomattox Canal. In 1795, a canal was dug to allow shipment of goods on small boats avoiding a shallow and rocky area of the Appomattox River. This canal ended in a basin that bordered High, South Commerce, and Dunlop Streets. In the early 1800s, factories, mills, and warehouses lined the banks. By the 1860s, the canal was still in use, but lack of maintenance had turned it into a millrace. Homes began being built in the square bordering the basin. During the Civil War, soldiers used it as a munitions and trade route. In 1908, Seaboard Railroad purchased the canal and filled it in, turning it into railroad tracks. (Courtesy of Jackson Davis Collection, Albert & Shirley Small Special Collections Library, University of Virginia.)

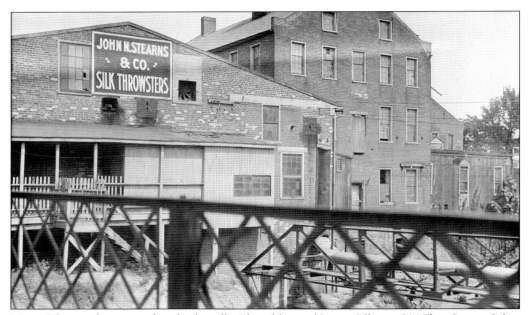

Mills. The canal supported multiple mills. The address of Sterns Silk was 544 Fleet Street. Other mills bordering the canal included Pride's Mill, Hope Flour Mill, McKenzie & Christian Cotton, and Merchants Island. (Courtesy of Jackson Davis Collection, Albert & Shirley Small Special Collections Library. University of Virginia.)

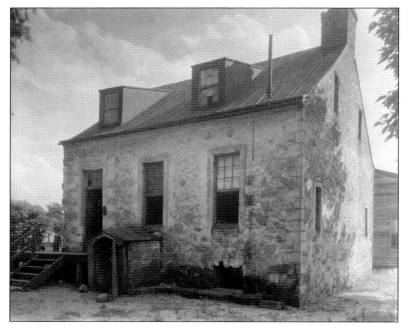

Stone House. Using the canal was not free. This stone house on Upper Appomattox Street was the tollkeeper's house. Built in the mid-18th century, it is where the canal turning basin was located. (Library of Congress.)

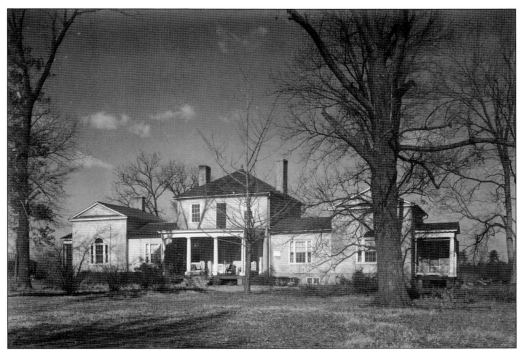

BATTERSEA, 1289 APPOMATTOX STREET. This property was built in 1768 by John Banister, one of America's Founding Fathers, Petersburg's first mayor, and a Revolutionary War colonel. During the American Revolution, the British troops commanded by Arnold and Cornwallis were camped there. This Palladian-style villa is unique to the city and has a rare 1820s orangery on the grounds. (Library of Congress.)

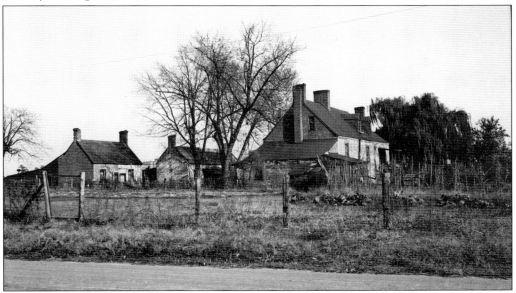

PRIDE'S TAVERN. Built in about 1820 on what is current-day Wells Street by Halcott Pride, as a public house, it served food and drink in addition to being a meetinghouse and pony express stop. In operation for 100 years, this image was taken shortly before it burned down in 1938. (Library of Congress.)

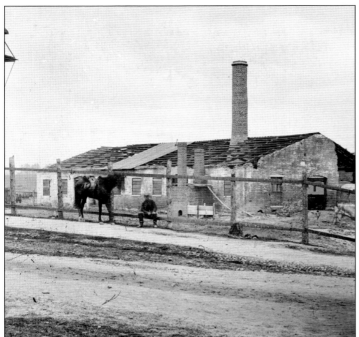

DESTROYED MILLS. In 1864, the city of Petersburg was under siege by the Union army. The mills were closed, warehouses became hospitals, and the people who worked in them became nurses and orderlies. In this image, taken in 1865, troops survey the damaged Johnson's mill. (Library of Congress.)

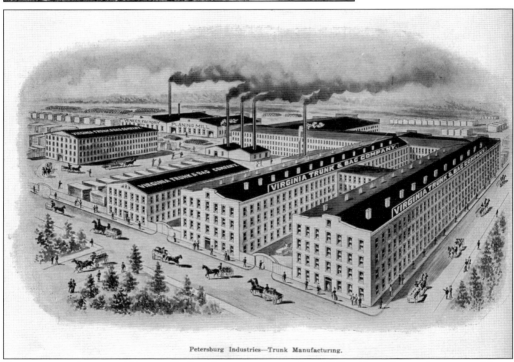

PETERSBURG BAG AND TRUNK. Railroad expansion in the 1870s allowed people to travel long distances, which created a need for luggage and trunks. In 1878, the Seward Company opened followed by at least nine other companies that made luggage components and hardware. The Petersburg Bag and Trunk complex was built between 1911 and 1938 on Dunlop Street. (Courtesy of the Southern Virginia Chamber of Commerce.)

LEAGUE CHAMPIONS, 1910. In the late 1800s, the Petersburg baseball park opened on McKenzie Street. The factories and warehouses had teams that competed against each other such as the Goobers, the Trunkmakers, and the Broncos. In 1914, the field was renamed McKenzie Park. It was the main baseball field in the area until 1959 when it moved to a neighboring town. (Courtesy of R. Gold.)

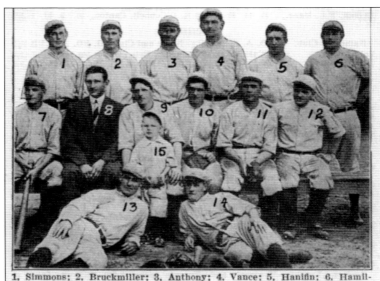

1, Simmons; 2, Bruckmiller; 3, Anthony; 4, Vance; 5, Hanifin; 6, Hamilton; 7, Spence; 8, Howedel; 9, Henry Busch, Mgr.; 10, Keliher; 11, Guiheen; 12, Booe; 13, Laughlin; 14, Selvage; 15, Henry Busch, Jr.
Copyright 1911, E. D. Magfee, Petersburg, Va.
PETERSBURG TEAM—CHAMPIONS VIRGINIA LEAGUE.

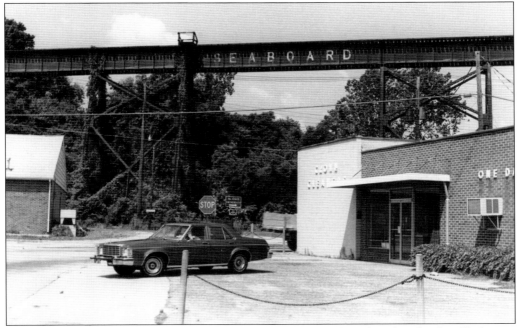

SEABOARD TRESTLE. In 1908, the canal was purchased by Seaboard Railroad, who filled it in, turning it into rail tracks. At that time, Petersburg's businesses were changing. In 1929, three railroads were running through the city. Between the 1920s and the 1940s, all the mills were closed. The neighborhood started to decline, By the 1980s, no railroads were operating in the city of Petersburg, and the Pride's Field District became low-income residential. (Courtesy of the Virginia Department of Historic Resources.)

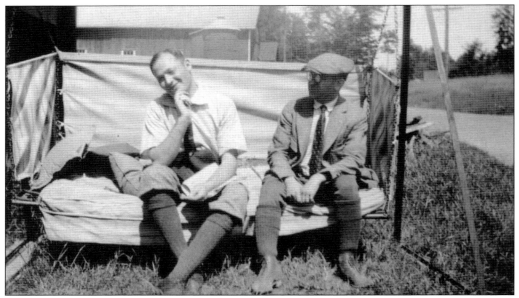

LORENZO STRINGER, 1925. Lorenzo Stringer lived at 335 Canal Street and is seen here in his front yard. This street looks the same 100 years later. The North Battersea-Pride's Field Historic District was put into the National Register of Historic Places in 2005. (Courtesy of Ann Doviken.)

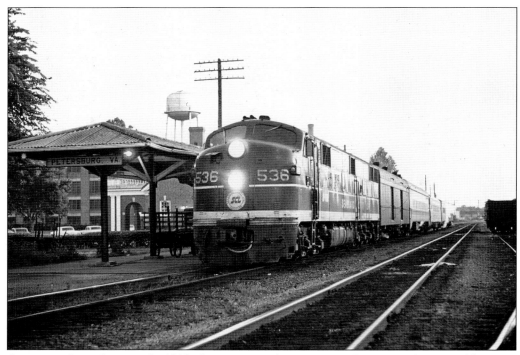

COMMERCE STEET STATION. In 1922, there were two businesses on Commerce Street, and by 1931, there were thirteen. Petersburg was the principal manufacturer of tobacco in the United States and the world's largest manufacturer of travel bags and trunks. Trains were the only way to transport the goods. This is the Commerce Street train station in about 1964. (Courtesy of Walt Gaye.)

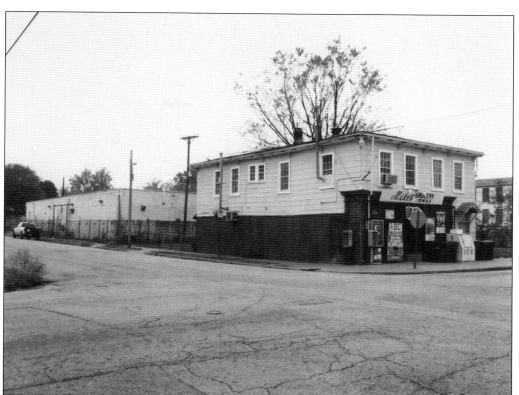

MIKE'S DELI. This corner store at 853 Commerce Street served the neighborhood for years. This property was built in 1860. It was quite common for a person to live above their store. (Courtesy of the Virginia Department of Historic Resources.)

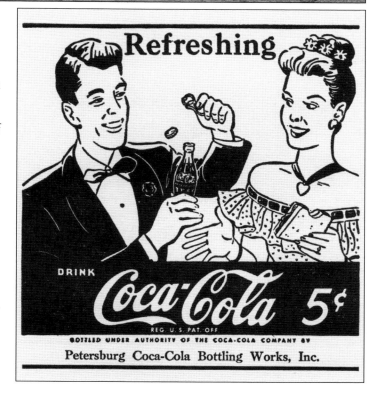

COCA-COLA AD. Coca-Cola Bottlers' original plant was on East Bank Street. The company outgrew the location, building a new larger fancier spot on West Washington Street in 1943. Pepsi bottlers opened a few years later across the street. (Courtesy of the Southern Virginia Chamber of Commerce.)

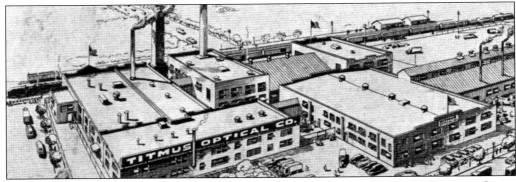

TITMUS OPTICAL. In 1902, Edward Titmus was a watchmaker with a store at 22 Sycamore Street, which was kept open until 1922. Founding Titmus Optical Company in 1908, by 1916, the company began making prescription eyeglass lenses. Opening a factory on Commerce Street in 1919, the company erected a building a year for 23 years, becoming the largest ophthalmic lens company in the United States. It was one of the industries highlighted at the 1939 World's Fair. In 1974, production started to dwindle and eventually closed in 1995. (Courtesy of R. Gold.)

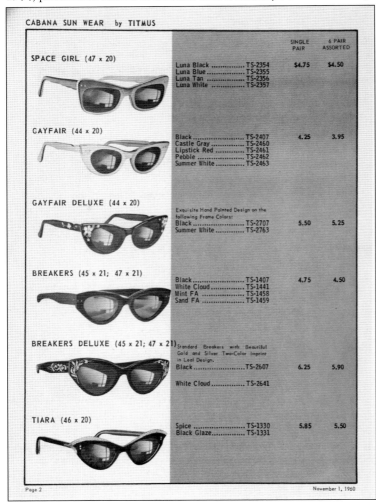

CABANA SUN WEAR, 1961. Making more than lenses, Titmus Optical Company frames were the height of fashion. (Courtesy of Albert & Shirley Small Special Collections Library, University of Virginia.)

Petersburg Industries—Flavoring Extracts Manufacturing.

EXTRACT AD. Southern Chemical erected two buildings at 800 Commerce Street. The company made extracts and Spartan aspirin. In 1939, the name was changed to Spartan Products Corp. The company closed in the late 1940s and was purchased by Titmus Optical in 1950. (Courtesy of the Southern Virginia Chamber of Commerce.)

HAVIN' FUN. John Moore was a janitor at Titmus Optical. This picture of Moore and friends was taken in 1946. In the center is John Moore. On his right is Sara "Hattie" Smith, who later became Hattie Moore. They were married for 37 years. (Courtesy of Hattie Moore.)

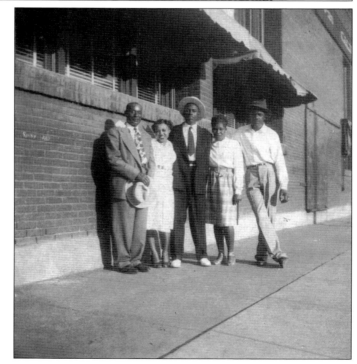

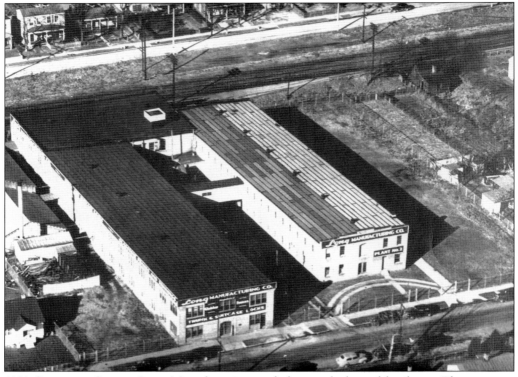

1131 COMMERCE STREET. Long Manufacturing made luggage locks and hardware. The company was in business from 1929 until 1995. (Courtesy of Long Lofts.)

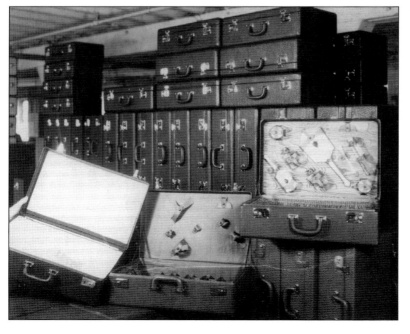

LUGGAGE DISPLAY. In 1939, the World's Fair, nicknamed "the World of Tomorrow," was held in Flushing, New York. Petersburg was the largest bag and trunk manufacturer in the world. This photograph was used in the Virginia Pavilion to show the world that Petersburg was an industry leader. (Courtesy of Library of Virginia.)

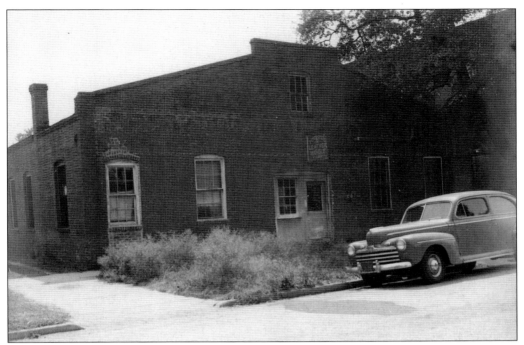

PETERSBURG LEATHER HANDLE FACTORY. Leather handles were an essential part of luggage. After World War II, the use of plastics and other synthetic materials caused the bag, trunk, and luggage makers to leave the city. The handle factory was on the edge of the Pride's Field Historic District on West Washington Street. (Courtesy of Albert & Shirley Small Special Collections Library, University of Virginia.)

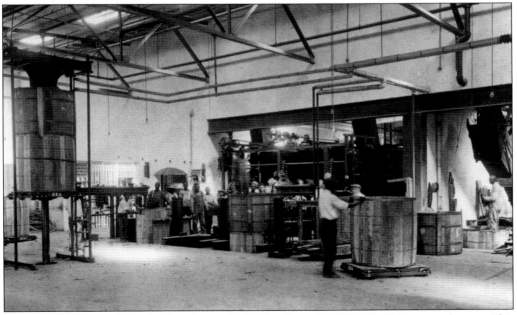

TOBACCO AUCTION. The third industry highlighted at the World's Fair was tobacco. This promotional postcard issued by tobacco company Watson and McGill reflects daily life in a tobacco warehouse. (Courtesy of the Southern Virginia Chamber of Commerce.)

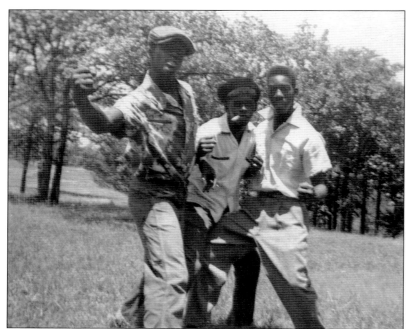

ALAN SIMS, MIKE, AND JOE. These three men are cutting up after work at Watson and McGill. The last tobacco company in Petersburg closed in 2010; its final location was in the Beach Tobacco building on Commerce Street. Alan, Mike, and Joe are pictured from left to right. (Courtesy of Alan Sims.)

COMMERCE AND DUNLOP, 2008. Businesses thrived until the mid-1990s, when the once-busy warehouses were closed and fell into complete disrepair. Commerce Street became a historic district in 2008 for the specific reason of allowing developers to apply for and use federal tax credits to rehabilitate the four warehouses for housing purposes. (Courtesy of the Virginia Department of Historic Resources.)

Four

Folly's Castle

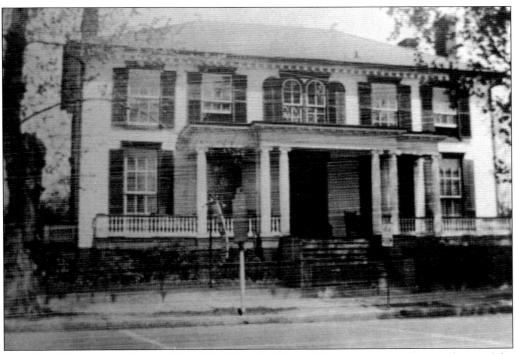

323 West Washington Street. The Folly's Castle Historic District is centered around one of the city's oldest homes. In 1763, Fort Henry and the surrounding area were inherited by Peter Jones V. He built a house and divided the rest of the land into 28 lots. His house is called Folly's Castle by the community because it is a huge home built by a man with no children. Jones died in 1769, willing his property to his niece. She and her husband sold the divided lots, and a neighborhood was born. (Courtesy of the Virginia Department of Historic Resources.)

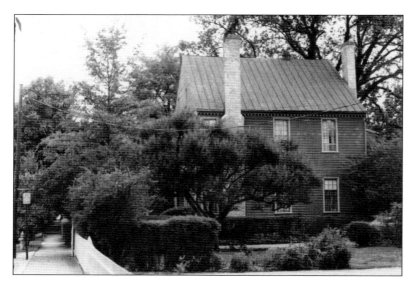

18 Perry Street. This was the home of Jonathon Smith. Built in about 1800, it was also a school that was attended by children of the city's most affluent citizens. (Courtesy of the Virginia Department of Historic Resources.)

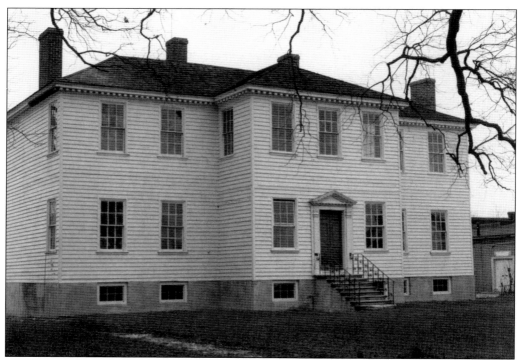

235 Hinton Street. This Federal-style tripartite home was built in 1792 by tobacco merchant William Barksdale. Named Strawberry Hill in 1827, it was the home of some of Petersburg's most important families. By 1880, it was divided into three sections, and it is now a bed and breakfast. It was put into both the US National Register of Historic Places and the Virginia Landmarks Register in 1974. (Courtesy of the Virginia Department of Historic Resources.)

26 Perry Street. This home was built between 1780 and 1790 by cotton broker Joel Hammond. Purchased by Attorney John Donnan in 1846, his descendants lived here until 1993. The basement has axe-hewn windowsills and was used as a bomb shelter during the Civil War. (Courtesy of the Virginia Department of Historic Resources.)

801 and 804 West Washington Street. The property at 801 Washington was the home and office of Dr. Charles Coach in the 1800s. In 1979, it was Bob's Laundromat. (Courtesy of the Virginia Department of Historic Resources.)

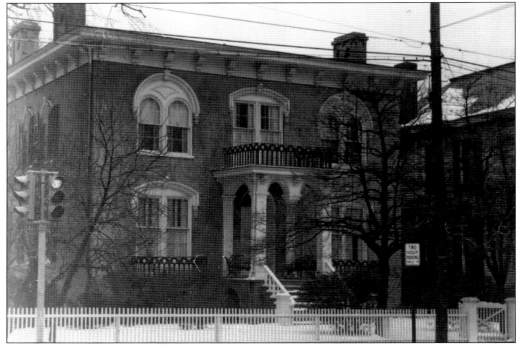

404 West Washington Street. The McIlwaine Friend House has its original 1858 matching cast-iron balconies. It was the home of Confederate captain Robert Dunn McIlwaine and served Maj. Gen. George Pickett as his headquarters during the Civil War. (Courtesy of the Virginia Department of Historic Resources.)

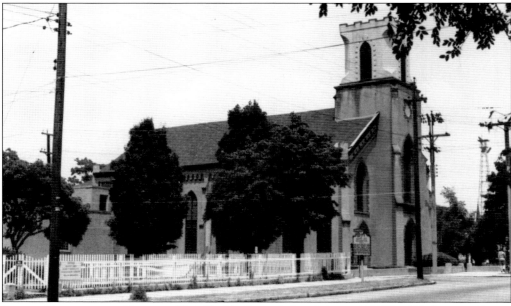

Second Presbyterian Church. This Gothic Revival church is on 419 West Washington Street, and its first pastor was Theodorick Pryor. During the Civil War, it was struck by artillery during a service, and its yard was used as a temporary cemetery. (Courtesy of the Virginia Department of Historic Resources.)

CIVIL WAR TROOPS ON WASHINGTON STREET. The 10-month siege of Petersburg ended on April 3, 1865. This photograph was taken as troops were leaving the city. The steeple of the Second Presbyterian Church is seen in the background. (*Harper's Weekly*, 1865.)

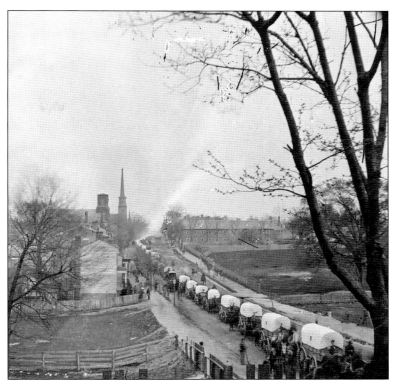

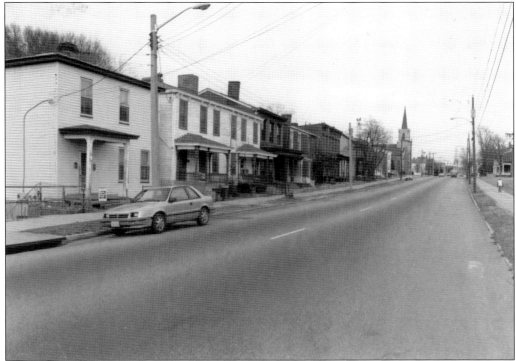

WEST WASHINGTON STREET, 1979. Same place 100-plus years later. The location is the corner of Hazel and West Washington Streets. (Courtesy of the Virginia Department of Historic Resources.)

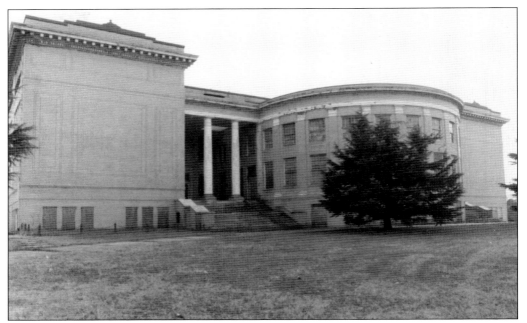

GOVERNOR'S SCHOOL. The neighborhood's first school was the Anderson Academy, built on Washington Street in 1821. In 1917, Petersburg High School was built on the foundation. Closed in 1974, it reopened as the Appomattox Regional Governor's School in 1999. (Courtesy of the Virginia Department of Historic Resources.)

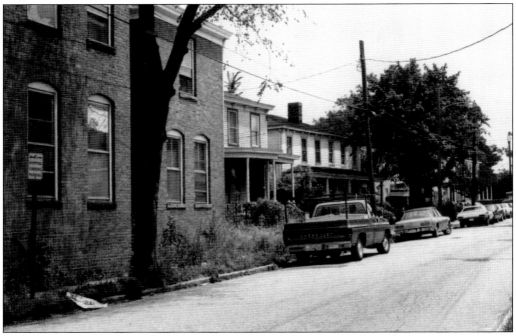

GUARANTEE STREET, 1978. The largest tobacco manufacturer was at the end of Perry Street. In the 1910s, the business dynamic of Petersburg began to change with the wealthy leaving the city. On Guarantee, Jones, Perry, Pine, and South Streets, many of the large houses were torn down and replaced by smaller modest homes. (Courtesy of the Virginia Department of Historic Resources.)

NEW STREET. Low-income housing was just two blocks away from the mansions on Washington Street. Seen here is an example of the shotgun shack. (Courtesy of the Virginia Department of Historic Resources.)

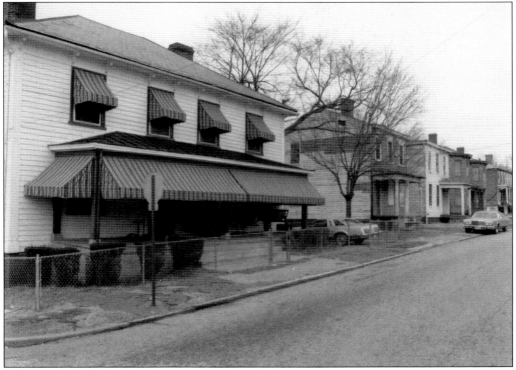

JONES STREET. Once called Jones Road, this is what an African American neighborhood looked like during Reconstruction. (Courtesy of the Virginia Department of Historic Resources.)

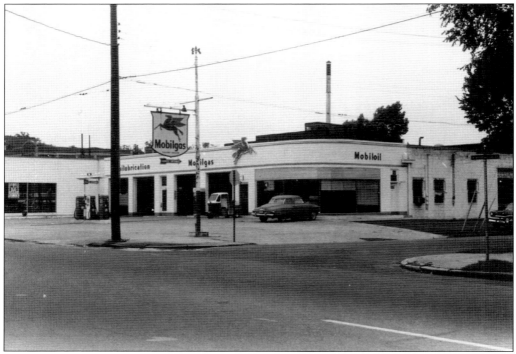

MOBILGAS STATION. This building on the corner of Washington and Guarantee Streets was a Mobilgas station. This was the only waterfall-style gas station in Petersburg. (Courtesy of Delta Oil Historic Archives.)

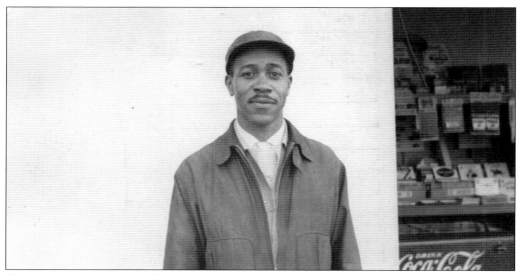

THURMAN SPRATLEY, 1956. Thurman Spratley was the owner of the Friendly service station on 400 South Jones Street. (Courtesy of Delta Oil Historic Archives.)

MAMIE CARVER, 1948. Mamie Carver lived on the corner of Pine and Lawrence Streets. Her husband was a shift foreman at Maclin-Zimmer-McGill tobacco. (Courtesy of Anthony Carpenter.)

WILLIAM WHITE. A veteran of World War II, William White is pictured in front of his home on Pine Street in the 1950s. Throughout the 1960s and 1970s, the tobacco company Brown and Williamson purchased and demolished entire blocks in this area to make room for production facilities. (Courtesy of Lynda White.)

SNOWMAN. Winters are mild in Virginia. During a rare snowfall in 1963, the crew at the fire station on South Street built a new member. (Courtesy of Fire Station No. 2.)

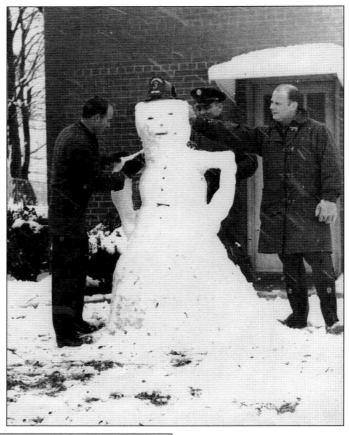

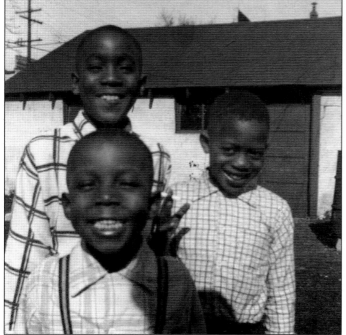

COUSIN P AND FRIENDS. Pictured from lower left to right are brothers Andy and Richard "Mookie" Brown with their cousin "P," short for Peter. Neighborhood old-timers may remember this group's antics. Here they are on New Street in the 1970s. The Folly's Castle Historic District was placed on the Virginia Landmarks Register in 1979 and the National Register of Historic Places in 1980, with boundary increases in both 1991 and 1999. (Courtesy of Alan Sims.)

Five

CENTRE HILL

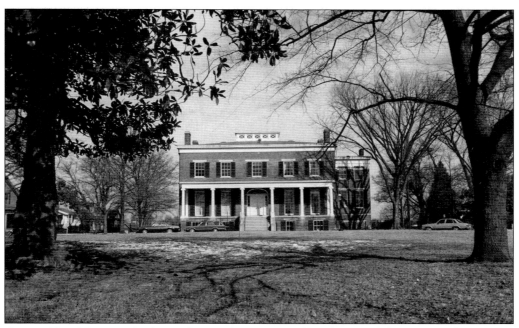

CENTRE HILL MANSION. In September 1812, a group of 75 volunteers left Centre Hill Square to fight in the War of 1812. In 1823, Robert Bolling IV built his new home on the square. (Courtesy of the Virginia Department of Historic Resources.)

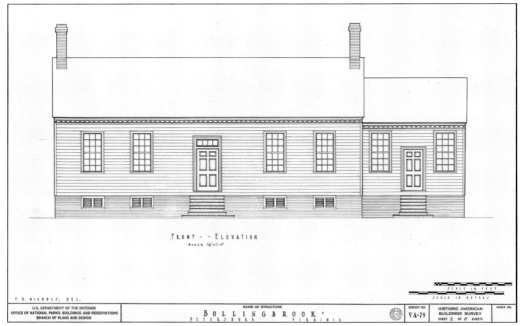

East Hill. Constructed prior to the American Revolution, East Hill was the home of the Bolling family. After the American Militia were defeated in the Revolutionary War, British major general Phillips made East Hill his headquarters. He died on May 13, 1781, and it then became the headquarters of Benedict Arnold. East Hill was demolished in 1958 to make room for the Interstate 95 ramp. (Library of Congress.)

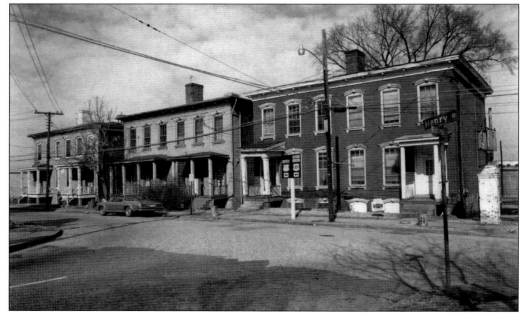

Henry Street. In the 1830s, Robert Buckner Bolling developed 70 lots, which became Adams, Franklin, Henry, Jefferson, Marshall, and portions of Washington and Wythe Streets. This new neighborhood was an upscale part of the city. (Courtesy of the Virginia Department of Historic Resources.)

Centre Hill North Porch. Robert Bolling IV died in 1839, willing his property to his son Robert Buckner Bolling. Centre Hill was remodeled both inside and out in the Greek Revival style, turning it into Petersburg's most stately home. It is rumored that Pres. John Tyler visited between the years of 1842 and 1845. Pres. William Taft visited Petersburg in May 1909 for the unveiling of the Hartranft monument. He spoke from the north porch. (Library of Congress.)

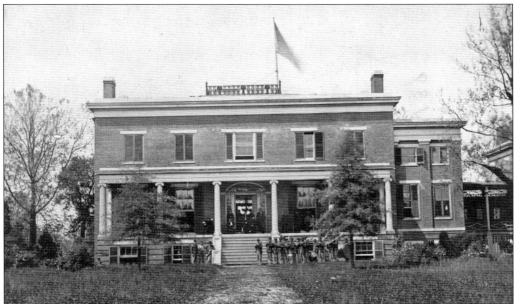

Troops at the Mansion. During the Civil War, Townshend Bolling continued to live at Centre Hill while it was used as the headquarters of Union major general G.L. Hartsuff. It suffered little to no damage. In April 1865, Pres. Abraham Lincoln was at the mansion. This is the oldest known photograph of the house. (Library of Congress.)

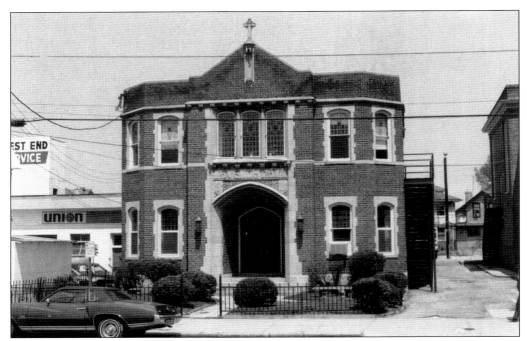

ST. JOSEPH'S SCHOOL. Founded in 1878, this school has provided high-quality education to residents for generations. (Courtesy of the Virginia Department of Historic Resources.)

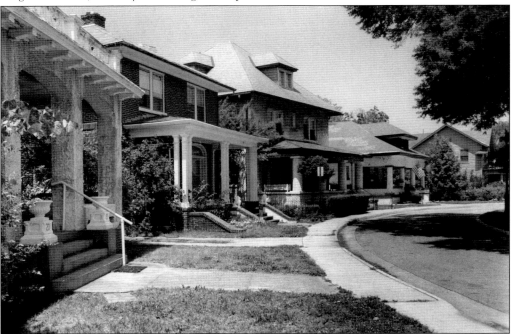

CENTRE HILL COURT. The mansion was purchased by Charles Hall Davis in 1901, who used it as his home and office until 1909. Facing financial issues he sold the property, except the house and courtyard, to John Hayes for $25,000. He started the Centre Hill Building Corp., breaking the property into 25 lots. Centre Hill Mansion was lot No. 1. (Courtesy of the Virginia Department of Historic Resources.)

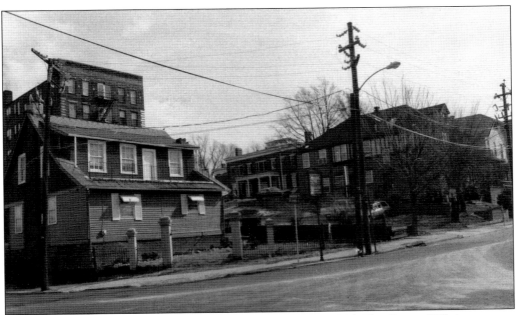

CENTRE HILL APARTMENTS. There was a population boom in 1915. The Centre Hill Apartments were built on Henry Street directly in front of the mansion. They were torn down in the late 1990s. (Courtesy of the Virginia Department of Historic Resources.)

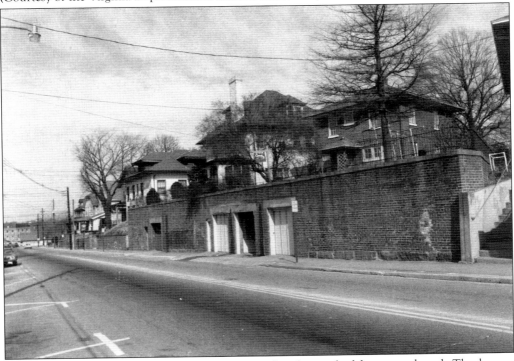

NORTH ADAMS STREET. By 1924, every home in this district had been purchased. The houses surrounding Centre Hill Mansion were favored by professionals. Cars were the new craze. Garages were built under the homes, and a stairway was constructed for those who had offices within walking distance of nearby downtown. (Courtesy of the Virginia Department of Historic Resources.)

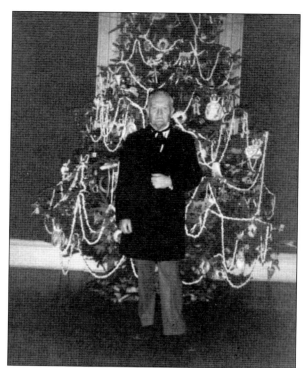

JAMES H. BAILEY, 1984. In 1936, Centre Hill was purchased at auction by Edgar S. Bolling, who donated it to the Park Service. It was included in the 1939 World's Fair catalog. During World War II, the mansion was used by the Red Cross. It has been a museum since the 1950s. This is James H. Bailey portraying Robert Bolling during Christmas at Centre Hill. Dr. Bailey was born in Petersburg and was the holder of more degrees and impressive job titles than can be listed. He was also the city historian and supervisor of Centre Hill Mansion. He authored numerous books and published articles. There was no social function that he did not attend. (Courtesy of Lynda White.)

LYNDA WHITE, 1990s. Due to its historical accuracy, Centre Hill Mansion has also been used in many movies. Pictured is local actress Lynda White in full costume ready for her scene. Centre Hill Mansion was put into the Virginia Landmarks Register in 1985 and the National Register of Historic Places in 1986, and the neighborhood was designated a historic district in 1986. (Courtesy of Lynda White.)

Six

COURTHOUSE HISTORIC DISTRICT

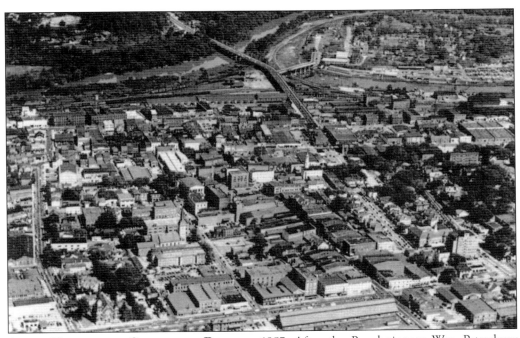

AERIAL VIEW OF THE COURTHOUSE DISTRICT, 1957. After the Revolutionary War, Petersburg was growing rapidly. By the mid-1800s, a financial district was complete with legal institutions and retail shops. During the Civil War, this area was a Union target, but after the war, the city rebounded, with the courthouse district becoming a business epicenter until the late 1900s. This 1957 image shows the district during its 20th-century heyday. At the time of publication, almost all the grand buildings are still utilized. (Courtesy of the Virginia Department of Historic Resources.)

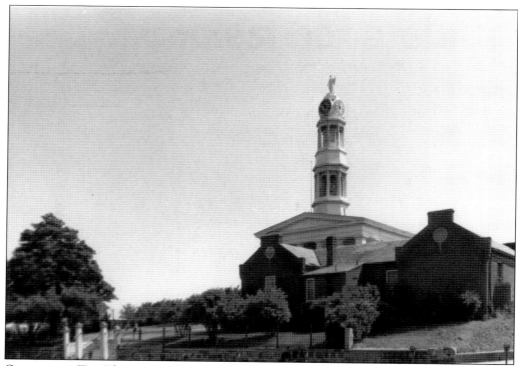

COURTHOUSE TOP. The city was booming by the late 1830s. Between 1838 and 1840, architect Calvin Pollard was commissioned to design a new courthouse in the Greek Revival style. The tower is modeled after the Choragic Monument of Lys. It has a double-tiered bell. In both 1846 and 1848, the men who volunteered to fight in the Mexican War met at the square before leaving. The scene was repeated in 1861 when the six companies that formed the Virginia Regiment left from the courthouse to fight in the Civil War. The tower was used as a sight by Union troops bombing downtown Petersburg. Hit by artillery at least three times, the clock never stopped running. On April 3, 1865, the siege ended when the Michigan sharpshooters overtook the courthouse. (Courtesy of the Virginia Department of Historic Resources.)

COURTHOUSE. March 1960 was the start of the civil rights movement. On March 8, Rev. Milton Reid led a prayer vigil on the steps in support of those arrested protesting segregation at the McKenney Library. That summer, protesters marched daily in front of the building. In 1961, a silent sit-in against school segregation took place on the steps. Another march and sit-in occurred in 1969 protesting police brutality. In 1993, the goddess was damaged during an F4 tornado. The statue was replaced in 2003. (Courtesy of the Virginia Department of Historic Resources.)

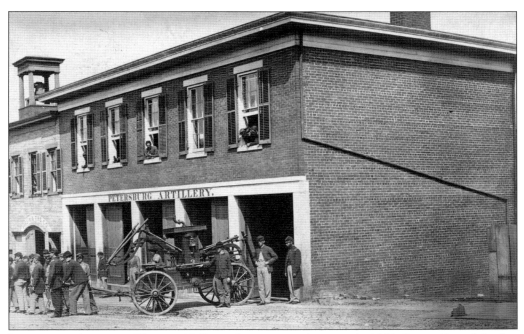

PETERSBURG ARTILLERY. The year 1843 saw the creation of present-day Tabb Street. One of the first buildings completed was the gun house, which safeguarded the artillery and ammunition needed to protect the city. Barely recognizable, this building is still in use. It is on the corner of Tabb and Market Streets. (Library of Congress.)

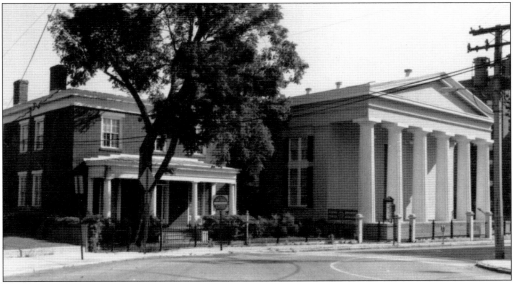

21 TABB STREET. Designed by famed architect Thomas U. Walter, Tabb Street Presbyterian was completed in 1843. It was one of the most impressive examples of Greek architecture adapted for worship in the country. The lobby has six fluted tin columns adapted from the Temple of the Winds. During the Civil War, the area under the steps was used as a bomb shelter. This church has its original bell, fence furnishings, pews, and organ. Missing is the steeple, as it was removed due to damage; it is on display at the Exchange Building. (Courtesy of the Virginia Department of Historic Resources.)

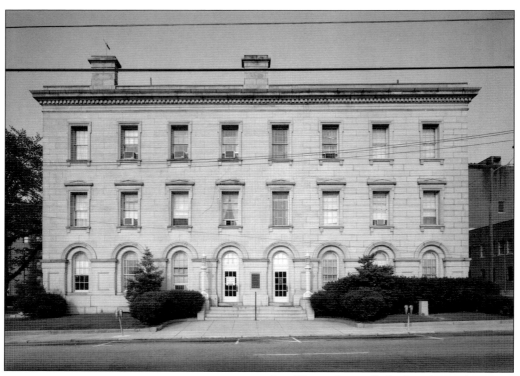

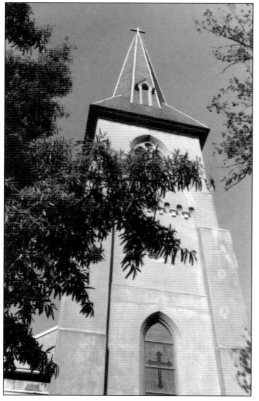

CITY HALL. Originally built to be used as a custom house, the structure was finished between the years 1856 and 1859. It was designed in the first Renaissance style by Ammi B. Young, supervising architect of the US Department of the Treasury, and constructed of local granite Its first purpose was to regulate the goods being shipped in and out of the city. It was the Confederate army's headquarters during the Civil War, with the Union troops using the roof as a site point. It was the post office until 1936 and has been used as a city hall since 1938. (Library of Congress.)

ST. PAUL'S EPISCOPAL CHURCH. Designed in 1855 by the architectural firm Niernsee and Neilson, this Gothic Revival church with its 175-foot steeple was dedicated on May 19, 1860. The rectory was completed the same year. During the siege, services continued while being used as a shelter. In 1867, the marriage of Robert E. Lee's son was held here. Behind the altar is a series of reredos depicting Christ's life, one of which was created by Louis Comfort Tiffany. (Courtesy of the Virginia Department of Historic Resources.)

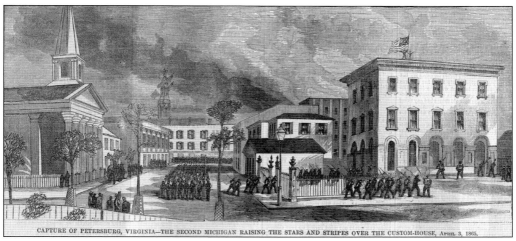

END OF THE SIEGE. On April 3, 1865, the battle for Petersburg was lost, and the 10-month siege was over. This sketch by Andrew McCallum depicts the 2nd Michigan Infantry Regiment raising the Stars and Stripes over city hall. (*Harper's Weekly*, 1865.)

SYCAMORE STREET STREETCAR. In 1882, George Beadle started the Petersburg Street Railway. In 1888, the first electric streetcar line started running a three-mile loop. This early 1900s postcard shows two on Sycamore Street. (Courtesy R. Gold.)

HOTEL PETERSBURG

Absolutely Fireproof and Modern

SAFETY SERVICE COMFORT

ALL ROOMS OUTSIDE EXPOSURE
LARGE, WELL LIGHTED SAMPLE ROOMS

DINING ROOM SERVICE A LA CARTE
ALSO

Club Breakfast..........................40 cents
Luncheon...............................65 cents
Dinner.................................90 cents

BLAND-ST. CLOUD OPERATING CO., Inc.

G. C. MORGAN, Mgr.

Associate Hotels: The Ricks, Rocky Mount, N. C.; The Bland, Raleigh, N. C.

HOTEL PETERSBURG. At 16-20 Tabb Street, this six-story Second Renaissance Revival hotel opened in 1915. Modern in every way possible, not only did it offer banquet facilities, a barbershop, and a writing room, but it was also fireproof. During the Cold War, a fallout shelter was built for guests. Its numerous original features include the barbershop, marble lobby, and staircase. In 2024, the Hotel Petersburg was recognized by the National Trust for Historic Preservation as a Historic Hotel of America. (Petersburg City Directory.)

THE GLOBE DEPARTMENT STORE. In 1903, the Globe opened. Located next to the courthouse and across the street from banks, insurance offices, and law firms, this store has been an active shop for 125 years. A rare example of an almost unaltered early-20th-century department store, it looks almost the same in 2024. (Courtesy of Anne Dovikan.)

W.M. Habilston & Co. This company sold carpets, furniture, and mattresses from its store at 20 North Sycamore Street. Owner William Habilston was also the president of Crystal Ice Co. This photograph was taken between 1890 and 1903. (Courtesy Albert & Shirley Small Special Collections Library, University of Virginia.)

Seaboard Terminal. In 1908, the canal was purchased by Seaboard Railroad, who filled it in turning it into rail tracks. The route was from Virginia going south with stopping points in the Carolinas, Georgia, and sunny Florida This building on the corner of North Market and Tabb Streets was the passenger terminal. (Courtesy of the Virginia Department of Historic Resources.)

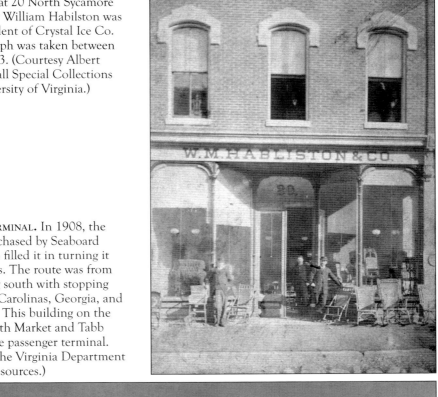

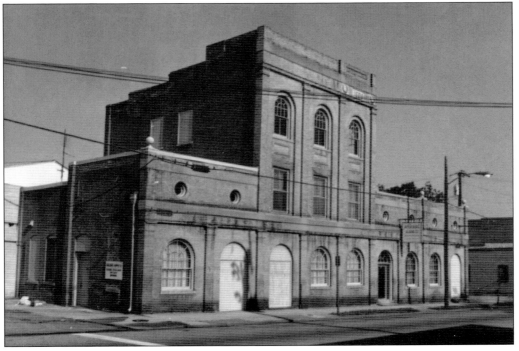

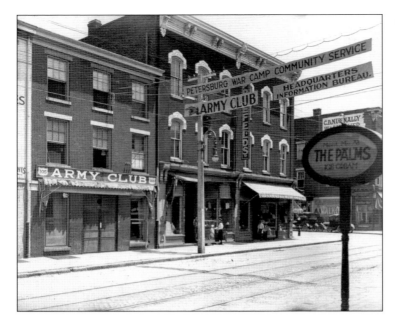

THE ARMY CLUB. The club opened in 1911 to give servicemembers stationed at Camp Lee a break from training and closed in 1921. The C.B. Nunnally shoe store is pictured in the background. Open from 1890 until 1922, the shoe factory was on the corner of Brown Street. (Courtesy of Library of Virginia.)

FRANKLIN STREET. The building on the right is the post office. Built in 1935, this building has its original flooring, post office boxes, teller windows, and two WPA murals depicting harvesting and hunting scenes. On the left is the Medical Arts Building. Constructed in 1935, it is one of the only examples of Art Deco architecture in Petersburg. (Courtesy of the Virginia Department of Historic Resources.)

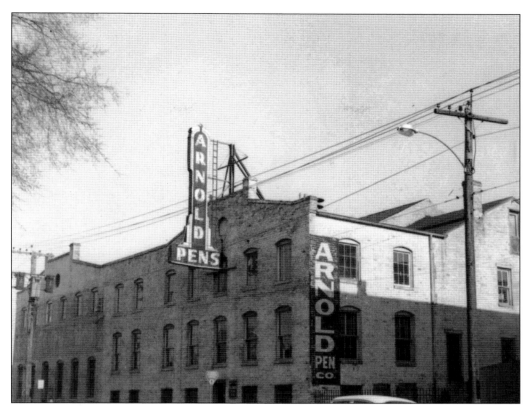

ARNOLD PENS. This business opened in 1935 on Washington Street, moving to 15 Union Street. It became the "second largest manufacturer of mechanical pencils and fountain pens in the world." In the 1950s, it began making ballpoint pens. (Courtesy of Petey Kaens.)

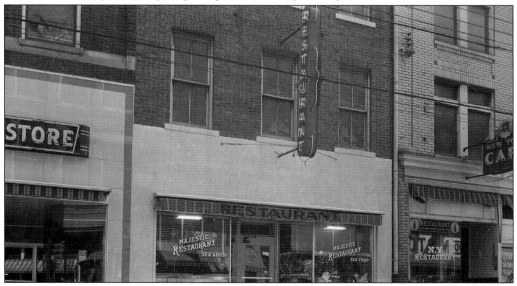

MAJESTIC RESTAURANT. In between Washington Street and current-day Wythe Street was 14 Sycamore Street, the Majestic. A few blocks from both the financial district and the industrial center, this row of buildings housed numerous restaurants until the 1990s. (Courtesy of Buck Ramsey.)

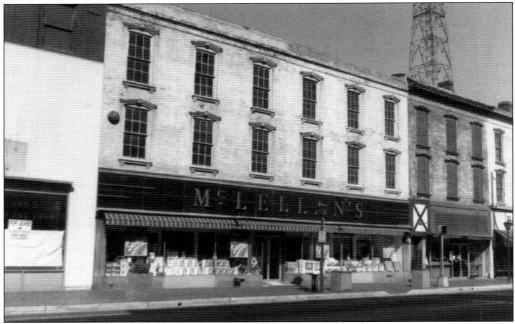

McLELLAN'S. On February 24, 1960, three groups of students from Peabody High School went to the lunch counters at Kreske, McLellan's, and W.T. Grant. Not only did they order, but they also sat down to eat and were then told to leave. They said no and stayed until the police were called. This was the first of many civil rights protests in the city. (Courtesy of the Virginia Department of Historic Resources.)

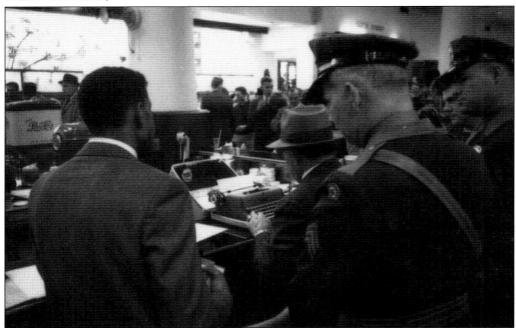

SIT-IN. This unidentified photograph from 1960 is the arrest of protesters at one of the lunch counter sit-ins. (Courtesy Richard Anderson MSS, Albert & Shirley Small Special Collections Library, University of Virginia.)

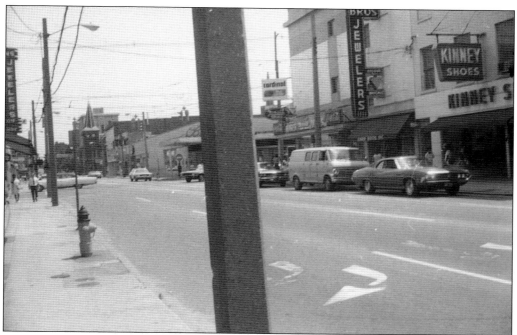

SYCAMORE STREET, 1973. Barr Brothers Jewelers was one of many jewelry stores on Sycamore. Its address was 6 North Sycamore Street from 1954 until 1986. The photograph above is of Sycamore Street and looks south toward Poplar Lawn. The view to the right looks north on Franklin and Sycamore Streets. (Both, courtesy of Dwayne Nelms.)

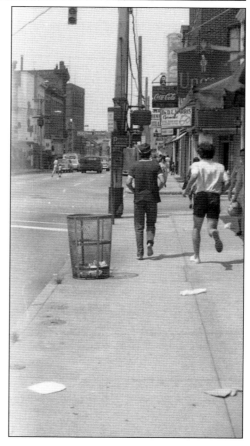

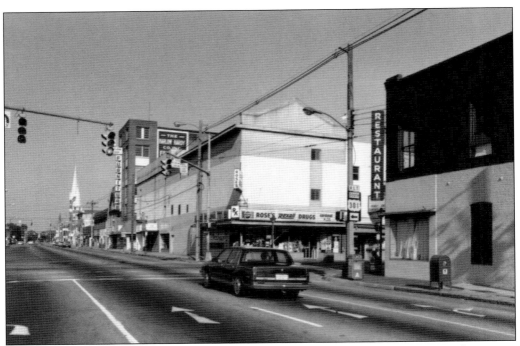

Sycamore, 1979. This view faces west toward Sycamore and Washington Streets. Rose's Rexall drugstore took up both 2 and 4 Sycamore Street open from 1954 until 2001. The Harlow Hardy Furniture on the corner of Washington and Union Streets was the city's oldest furniture store, open for over 100 years. This corner, almost unchanged from the early 1900s, is the most photographed corner in Petersburg. (Courtesy of the Virginia Department of Historic Resources.)

Historical Approval. In 1990, the area surrounding the courthouse was put into the National Register of Historic Places, preserving this rare business district for future generations to appreciate. (Courtesy of the Virginia Department of Historic Resources.)

Seven
Poplar Lawn

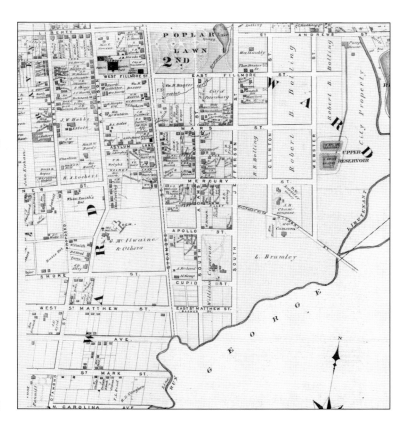

Map, 1878. In 1752, Halifax was the only street on the west side of Petersburg. Robert Ravenscroft divided his farm into three-acre housing lots called Ravenscroft. Harrison, Harding, and Liberty Streets are original to his grid. The land from Harrison Street to St. Andrews Street belonged to Robert Bolling, who, in 1809, began carving out and selling lots. The land in the center was a mule pasture that was starting to be used as a recreational area. (Courtesy of the Virginia Department of Historic Resources.)

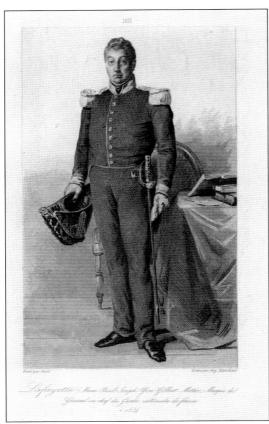

GENERAL LAFAYETTE. In 1781, troops led by the Marquis de Lafayette were located in neighboring Colonial Heights bombarding British troops that were occupying Petersburg. After the Americans' victory at Yorktown, the Revolutionary War general was a superstar. In 1824, he was invited to the United States by President Monroe as America's guest. In October a celebration in his honor was thrown at the training green, now known as Poplar Lawn Park. It was attended by all. (Library of Congress.)

200 BLOCK OF SYCAMORE STREET. Between 1830 and 1910, the grandest homes in Petersburg were built around Central later known as Poplar Lawn Park. The most impressive are still standing on South Sycamore. The two houses in the foreground were built by Reuben Ragland for his daughters in the 1850s. (Courtesy of the Virginia Department of Historic Resources.)

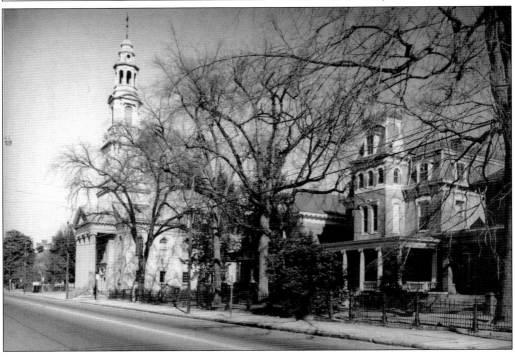

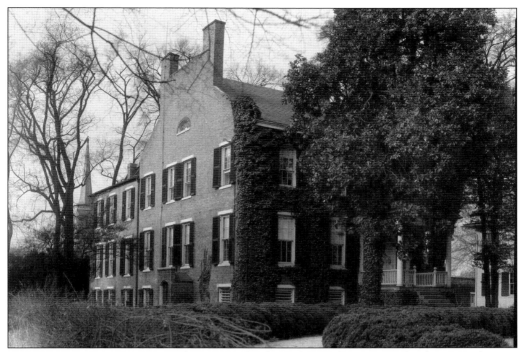

THE BOLLING ZIMMER HOUSE. Built in 1830, this home has such impressive landscaping, that it is known as "the Lawn." Robert E. Lee visited the house in 1867 when a local girl, Mary Tabb Bolling, married his son. Later purchased by W.L. Zimmer of Zimmer & Co., engravers and booksellers, it is just one of many astonishing homes on this street. (Library of Congress.)

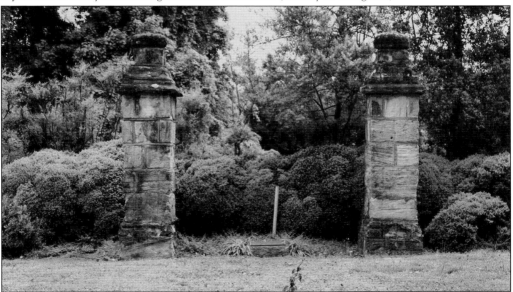

MARSHALL STREET PILLARS. A mansion known as Spring Hill was Petersburg's first courthouse. It was on Tabb Street. When it was torn down in 1850, the pillars from the front gate were relocated to the end of Marshall Street, overlooking the reservoir. Under the pillars is a plaque mentioning Gene Farinholt. He lived on South Jefferson Street and was the ticket agent at Fort Lee, an avid gardener, and a beloved member of the community. (Courtesy of L. Charboneau.)

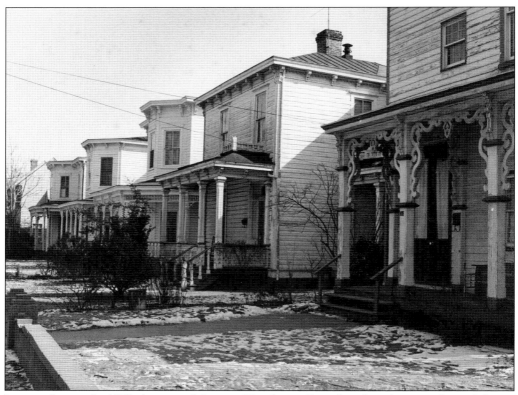

LIBERTY STREET. In 1850, doctor and druggist Hawthorne Rives bought a three-acre lot on Liberty, which he split into six parcels. Dr. Robert Broadnax then built 116 Liberty Street, which was one of the most beautiful Renaissance Revival homes in the city. The street is known for its Eastlake-style porch supports. (Courtesy of the Virginia Department of Historic Resources.)

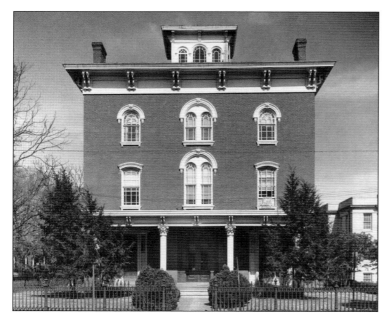

RAGLAND MANSION. Reuben Ragland was a commodity broker who became so wealthy that in 1856, he built this Italianate mansion on Sycamore Street and built equally impressive homes for his daughters on neighboring lots. During World War I, General Pershing stayed here. Joseph Cotton was an actor during Hollywood's Golden Age. A Petersburg native, this was his family's home. (Courtesy of Petey Kaens.)

CIVIL WAR. The city purchased the training green for $15,000 in 1846. It became known as Central, or Poplar Lawn, Park. In 1861, it was once again a training ground. During the Civil War, this was the site of a field hospital. After the Battle of the Crater on July 30, 1864, a retention camp for captured Black soldiers was set up in the park. Major supply and troop movement routes were South Sycamore and Halifax Streets. Many homes were damaged by shelling. (Library of Congress.)

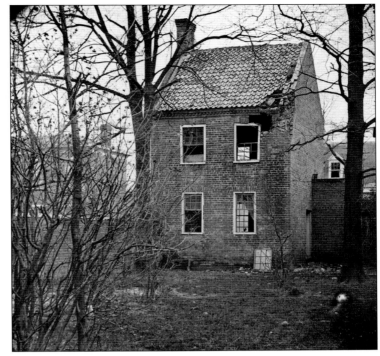

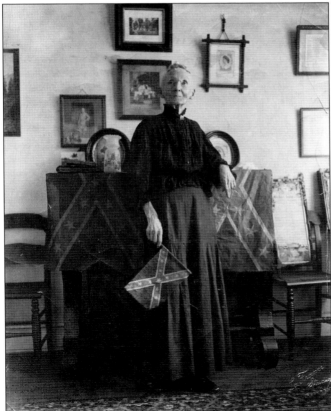

NORA FONTAINE DAVIDSON. Nora Davidson was a local teacher who lived on South Adams Street. In 1861, she organized local women to raise funds in support of the Ragland Guard, which later became the Virginia 41st Infantry, Company 6. She entertained the first troops entering the city. During the war, she was instrumental in the creation of hospitals. Multiple members of her family were war casualties. On June 9, 1865, she and her students laid flowers on graves at Blandford Cemetery, witnessed by a group of women including Mary Logan, wife of the commander of the Grand Army of the Republic. She was so touched by this Southern tradition, she relayed the story to her husband. This helped inspire National Decoration Day, which later became Memorial Day. (Courtesy of Petey Kaens.)

POPLAR LAWN BANDSTAND. By the year 1870, the park was in disrepair. The city was considering turning Poplar Lawn Park into a residential area. Citizens spoke up, and plans were changed. Improvements to the park were made between 1873 and 1875. New paths were installed, a pond with a bridge was created, ornamental trees were planted, and a bandstand was built. (Courtesy of the Virginia Department of Historic Resources.)

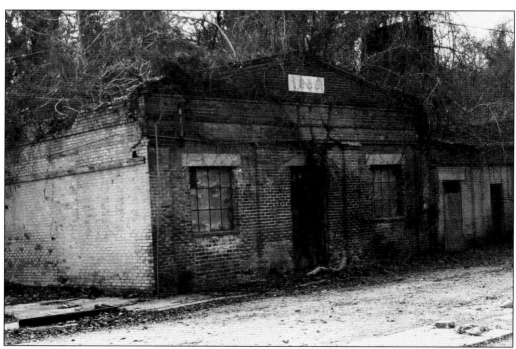

PUMP STATION. The first waterworks, at the end of St. Andrews Street, opened in 1856. It was fed by two reservoirs, operated on a gravity system, and supplied the entire city. In 1888, a new, modern building was constructed. (Courtesy of the Virginia Department of Historic Resources.)

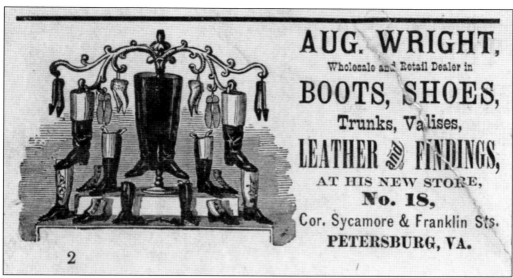

AUGUSTUS WRIGHT SHOES. Augustus Wright was president of Augustus Wright Shoes, Virginia National Bank, and Virginia Consolidated Milling. He was also the vice president of Virginia Passenger and Power Co. and Jackson Coal. Plus, he owned a leather goods warehouse that produced and sold the finest leather bags, shoes, and accessories. This advertisement appeared in the 1889 city directory. (Courtesy of the Petersburg City Directory.)

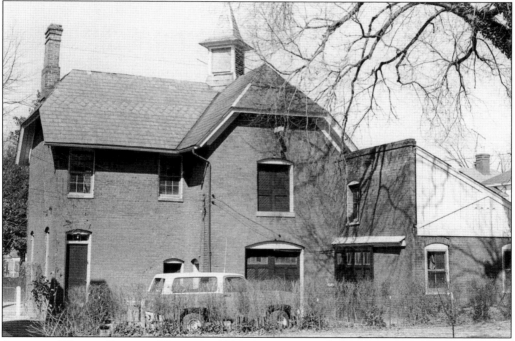

AUGUSTUS WRIGHT CARRIAGE HOUSE. In 1899, Augustus Wright built a Queen Anne–style house next to Poplar Lawn Park. The largest house on the street is rumored to have been the first house to become electrified. Wright was so wealthy that he had a matching carriage house built next door to his house. This is one of multiple examples of turn-of-the-century outbuildings in the city. (Courtesy of the Virginia Department of Historic Resources.)

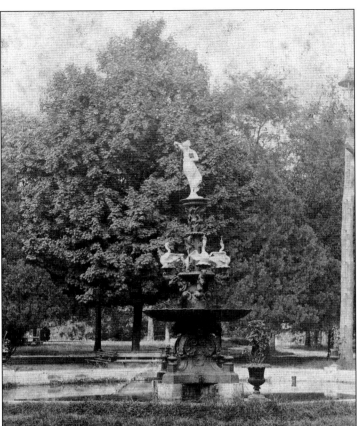

POPLAR LAWN FOUNTAIN. In the 1870s, the park was improved. A new ornate fountain was installed. In 1955, the fountain pictured in this 1901 photograph was donated to Richard Bland College. (Courtesy of Library of Virginia.)

MLK SAFE HOUSE. Petersburg had a huge part in the civil rights movement. Dr. Martin Luther King Jr. visited six times between 1956 and June 1967. When here, the Jones family hosted his visits. He ate meals prepared by Josephine Jones, slept in the guest room, and conducted meetings in the den of their home at 514 Harrison Street. (Courtesy of L. Charboneau.)

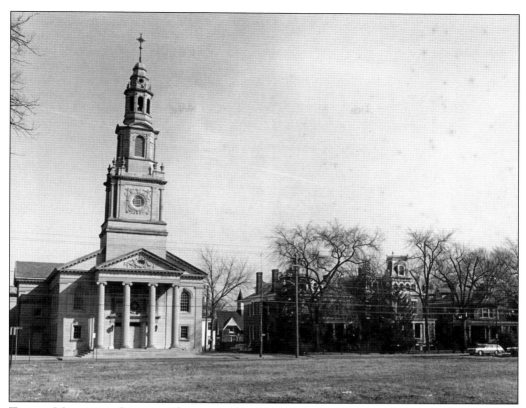

TRINITY METHODIST CHURCH. The ground breaking of the neighborhood's newest church was in 1920. Designed by architect R.E. Mitchell, it has stunning windows and one of the tallest steeples in the city. When Augustus Wright died in 1928, his sister Catherine donated a painting titled *The Transfiguration to the Church*. It is still hanging after 100 years. (Courtesy of the Virginia Department of Historic Resources.)

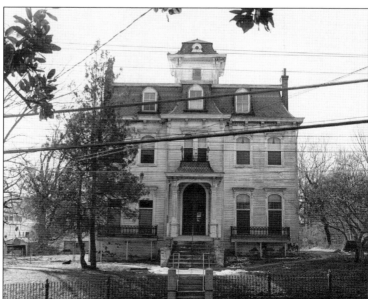

228 SOUTH JEFFERSON STREET. Thi Second Empire home with decorative ironwork was the home of produce importer George Davis in 1889. (Courtesy of the Virginia Department of Historic Resources.)

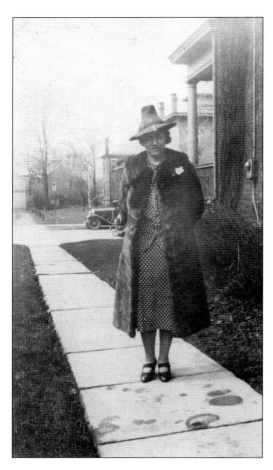

Carrie Ryan, 1942. Carrie's posing in a terrific hat on Fillmore Street. Around the corner from Carrie on Webster Street, there was a water distribution reservoir. A block away on South Adams and Mars was the J.R. Ayers Agricultural Implements Foundry. (Courtesy of Tony Carpenter.)

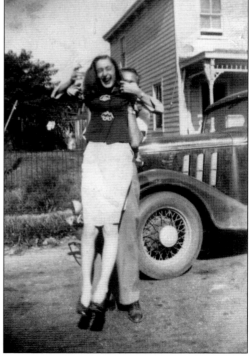

Young Love. William and Victoria White lived on South Adams Street when they were first married. At that time, there was an electric substation on Webster Street where the reservoir had been. (Courtesy of Lynda White.)

McKenney Library. The property at 137 South Sycamore Street was built in 1859 by Petersburg's first elected mayor, John Dodson. After the Civil War, it was the home of Confederate-turned-reconstructionist Gen. William Mahone. In 1923, Clara McKenney donated it to be the city's first public library. The deed stated that the basement was to be used by persons of color. On February 27, 1960, the first library sit-in protesting segregation in America was held here. The building was closed from July until November 1960 when all city buildings in Petersburg became integrated. (Courtesy of the Virginia Department of Historic Resources.)

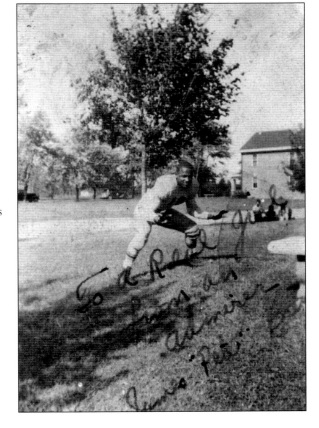

Pete Brewer. The Brewers lived on St. Matthews Street. Here, Pete Brewer tries to impress "a Real Girl." (Courtesy of Hattie Moore.)

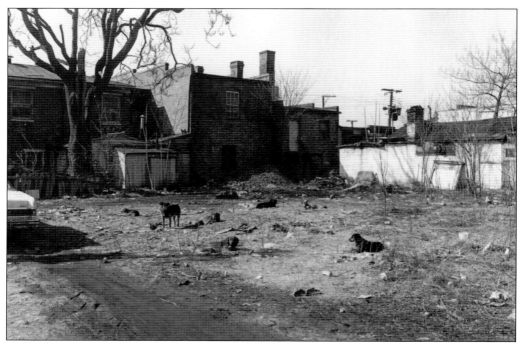

How Many Dogs? Petersburgers really love their pets. This pack has an entire lot off Corling Street as their personal playground. (Courtesy of the Virginia Department of Historic Resources.)

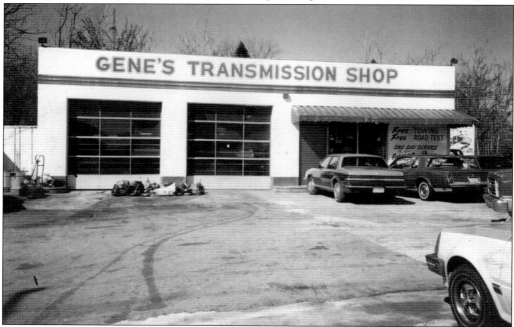

Shore and Sycamore Streets. In 1900, this was the end of the city. There was a graveyard here and farmland to the north. Gene's Transmission Shop serviced the neighborhood's automotive needs from 1981 until 2024. The Poplar Lawn Historic District was entered into the Virginia Landmarks Register in 1979 (with an extension in 2005) and the National Register of Historic Places in 1980. (Courtesy of Gene's Transmission Shop.)

Eight
SOUTH MARKET AND ATLANTIC COAST LINE

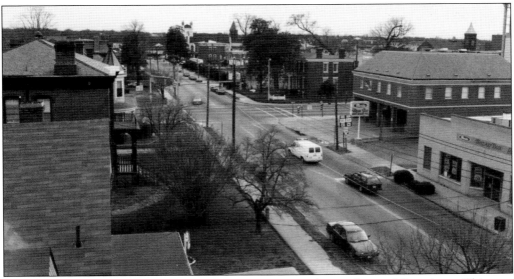

SOUTH MARKET STREET. In 1786, Market Street was on the outskirts of Petersburg. This area belonged to the family of Erasmus Gill, who had split it into one-acre lots, calling the area Gillsland. A few homes were located here in 1815. In the 1840s, Petersburg was a prosperous city with new homes being constructed on South Market Street. Known as the Fifth Avenue of Petersburg, for a few years, this was where the most influential members of high society lived. (Courtesy of the Virginia Department of Historic Resources.)

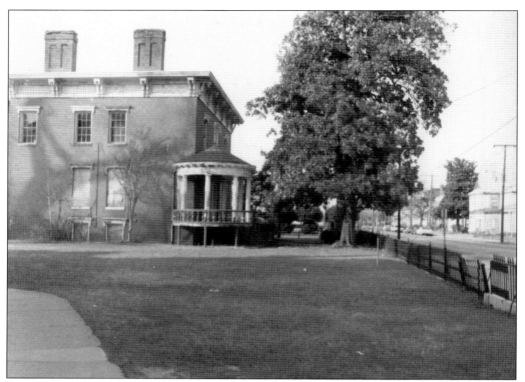

WALLACE HOUSE. The home at 204 South Market Street was built by attorney Thomas Wallace in 1855; with both Greek Revival and Italianate features, it is one of the most impressive homes in the city. This was Union general and future president Ulysses S. Grant's Civil War headquarters. On April 3, 1865, Pres. Abraham Lincoln came here to discuss leniency for the South after the surrender at Appomattox. During his 1909 visit, President Taft stopped here for a drink of water. (Courtesy of the Virginia Department of Historic Resources.)

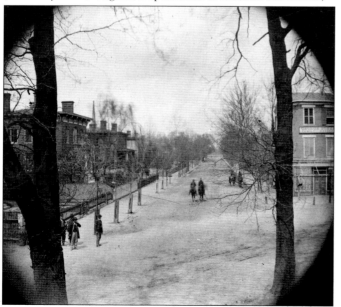

STREET SCAPE, 1865. Petersburg was put under siege by Union troops. The families that lived here left, and fighting downtown and along the riverfront was intense. These mansions, only two blocks away, were spared from destruction because they were used as headquarters by both Confederate and Union leaders. (Library of Congress.)

29 South Market Street. The Scott House is one of the most beautiful homes in this district. It was built in 1858 by clothing merchant A.L. Scott in the Italianate style, but Scott never lived here. It was purchased by the Romaine family in the 1880s, who lived here for over 100 years. (Courtesy of the Virginia Department of Historic Resources.)

106 South Market Street. Jane McIlwaine married John Stevenson in 1850. This home was built for her by her father, and her sister lived in a duplicate house next door. In the 1970s, this was the home of local historian Edward Wyatt. Allen, Allen, Allen & Allen have been practicing law out of the home since 1988. Pictured next door is firehouse No. 2. (Courtesy of the Virginia Department of Historic Resources.)

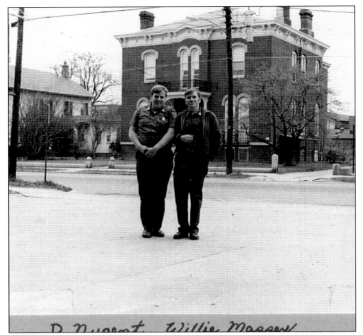

FIREMEN. Paul Roper was the president of Roper Wholesale Grocer. Built in 1850, his home is one of the most interesting on the street. Pictured here are Dick Massey and Wille Nugent of Fire Station No. 2 in 1978. (Courtesy of Fire Station No. 2.)

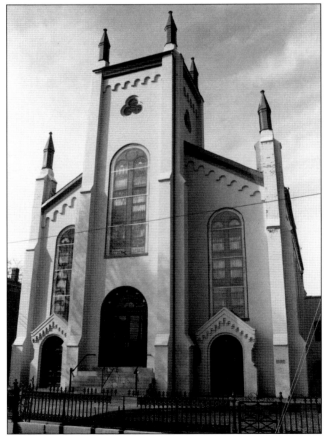

CHURCH OF THE ARISTOCRACY. The church at 1875 South Market Street was built in the Gothic Revival style and was nicknamed "the Church of Methodist Aristocracy." In 1895, the church purchased a 300-pipe organ so large that an addition had to be built. By the 1910s, Petersburg's business environment started to change, as wealthy families moved. The area started to decline. The church became the First Christian in 1924, then Mount Olivet Baptist in 1954. Currently, it is the House of Restoration. (Courtesy of the Virginia Department of Historic Resources.)

133 South Market Street. In 1895, the first middle-class home was built, signifying an economic change. This home was owned by G.S. Talbot, a foreman at Export Leaf Tobacco. (Courtesy of Virginia Department of Human Resources.)

W.H. Harrison Ad, 1923. The dynamic of South Market had changed by the 1920s, as retail stores were being built on each corner. (Courtesy of the Petersburg City Directory.)

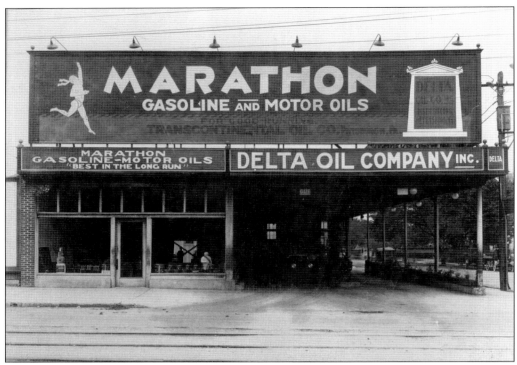

MARATHON STATION, MARKET STREET. One of the first stations opened in Petersburg, this photograph was taken around 1930. (Courtesy of Delta Oil Historic Archives.)

CORNER OF MARKET, BYRNE, AND HALIFAX STREETS, 1970s. An area totally unrecognizable, this is now one of the most depressing areas of the city. The South Market Street Historic District was entered into the National Register of Historic Places in 1992. (Courtesy of the Virginia Department of Historic Resources.)

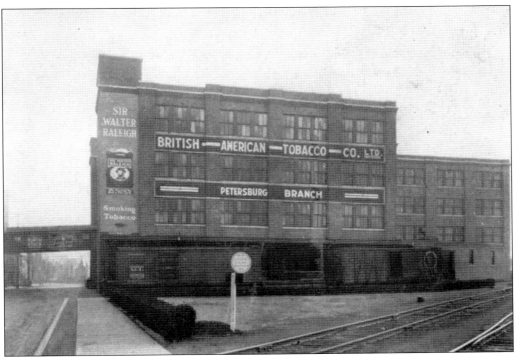

Cameron Tobacco. In 1858, William Cameron invented a tobacco press. In the 1860s, he and his brothers had a contract selling tobacco to the British Navy, and by the end of the decade, they were worldwide exporters. During the Civil War, this building was used as a hospital. In 1879, a new warehouse was built on the corner of Brown and Perry Streets. Cameron Tobacco was sold to British American Tobacco in the late 1890s. Purchased by Brown and Williamson in 1932, the property is currently an apartment building. (Courtesy of Albert & Shirley Small Special Collections Library, University of Virginia.)

Export Leaf Tobacco. This company's original warehouse was on East Bank Street. Moving to Brown and Perry Streets in 1902 right next to British American, it specialized in plug and twist tobacco and became the biggest exporter in the country. (Courtesy of Library of Virginia.)

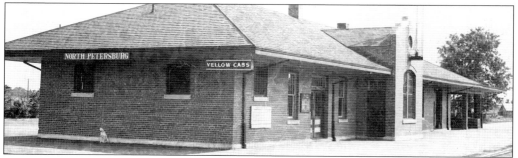

ACL TERMINAL. The Atlantic Coast Line merged with the Richmond & Petersburg Railroad lines in 1898. In 1902, the rail line began transporting goods and people from a terminal that encompassed the entire block from Washington Street to Brown Street. The terminal pictured was built in the early 1940s. (Courtesy of Walt Gaye.)

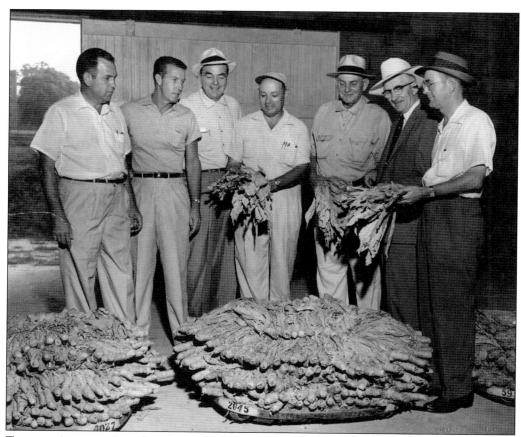

TOBACCO AUCTION. Petersburg was the principal manufacturing center of the country by 1922. This is a promotional photograph that was used in the 1939 World's Fair. (Courtesy of S. Chapell.)

CHILD LABOR. The National Child Labor Committee sent photographer Lewis Hines to Petersburg in 1911. He documented the living and working conditions of both children and adults. This image was taken at British American Tobacco. (Library of Congress.)

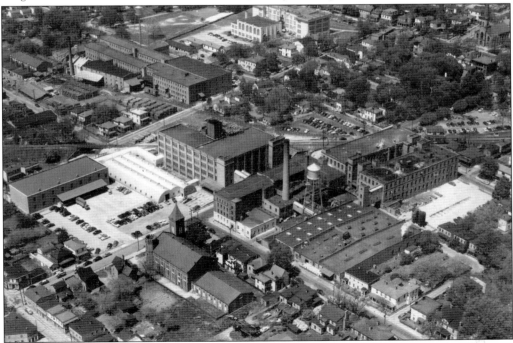

BROWN AND WILLIAMSON. In 1927, British American Tobacco purchased Brown and Williamson Tobacco. In the 1930s, they began dominating Petersburg's tobacco industry, becoming the city's largest employer. The Brown and Williamson complex is in the center of this 1958 aerial photo. The company moved to Georgia in 1985. (Courtesy of the Southern Virginia Chamber of Commerce.)

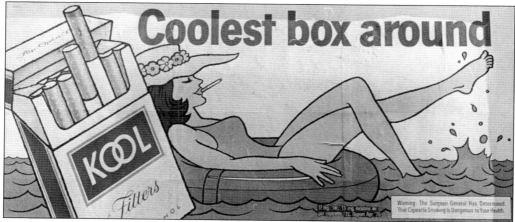

KOOL AD, 1976. Brown and Williamson made many brands. Kool cigarettes, manufactured in Petersburg, were the first menthol brand to be advertised and marketed nationally. Viceroy was also made in Petersburg and was the first brand to use filter tips. (Courtesy of S. Chapell.)

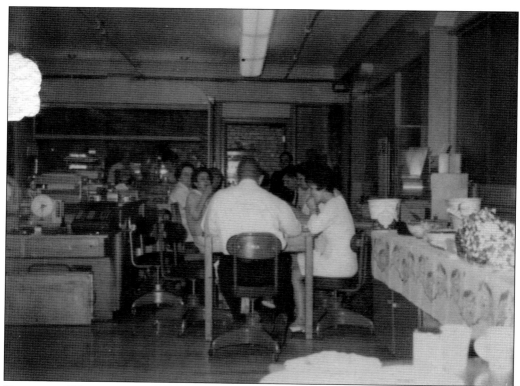

BROWN AND WILLIAMSON CAFETERIA. This is what the cafeteria of the city's largest employer looked like at Christmas. The Atlantic Coast Line Railroad Commercial and Industrial Historic District was put into the National Register of Historic Places in 2009 and the Virginia Landmarks Register to allow developers to apply for grants and use federal tax credits to rehabilitate the tobacco building for housing purposes. (Courtesy of Lynda White.)

Nine
HALIFAX TRIANGLE

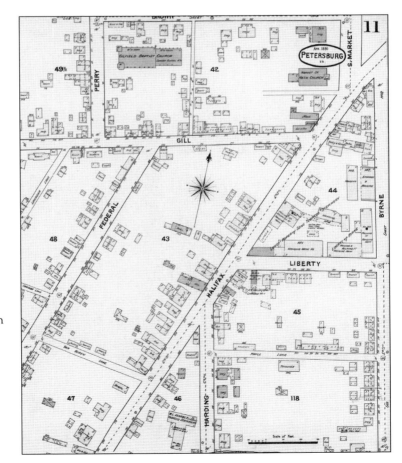

SANBORN MAP, 1915. In 1787, on his land just outside of the city limits, Erasmus Gill created the main streets, Halifax, Union, Market, and Washington, and divided them into lots. By 1790, this area was being called "Gills Field," with Halifax Street being the main road into North Carolina. This area extended south, becoming the Delectable Heights and Halifax Triangle neighborhoods. Petersburg's population in the early 1800s was about 50 percent Black or mixed race, with one-third of that being free. Freemen were legally able to own property and businesses. (Library of Congress.)

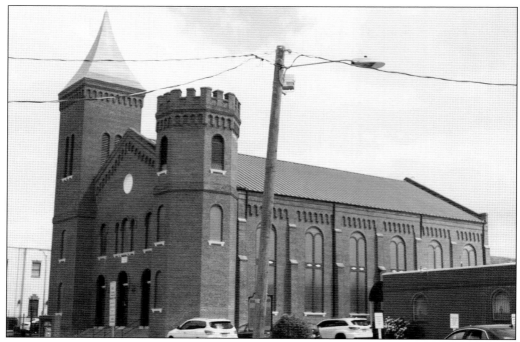

GILLFIELD BAPTIST CHURCH. Sandy Beach Baptist Church, an African American church in the town of Pocahontas, purchased a lot on Perry Street in 1818. The original church burned, was rebuilt in 1858, and named Gillfield Baptist. Henry Williams was pastor from 1865 to 1890. He was the first African American elected to city council. In 1953, Wyatt T. Walker was pastor. A civil rights leader, he was cofounder of the Southern Christian Leadership Conference. Church member Dorothy Cotton became close friends with Martin Luther King Jr., making countless contributions to the civil rights movement. In 1970, Gillfield was the first Baptist church to ordain female deacons. (Courtesy of L. Charboneau.)

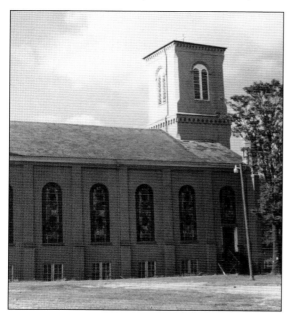

FIRST BAPTIST CHURCH. In 1830, the Free African Church was built on Harrison Street. In 1878, the congregation built a new church on the corner of Harrison and Liberty Street. In the 1880s, they opened the first Black school in America. In 1958, the pastor was Milton Reid. His classmate and friend Dr. Martin Luther King Jr. visited the church, which became a cornerstone for civil rights planning. On March 5, 1960, Pastor Reid held a prayer vigil in the parking lot, raising $1,500 to go toward bailing out those arrested at the library. That June, he led a protest ending segregation at the hospital. In 2024, First Baptist Church was awarded the distinction of having the oldest continual African American congregation in America. (Courtesy of the Virginia Department of Historic Resources.)

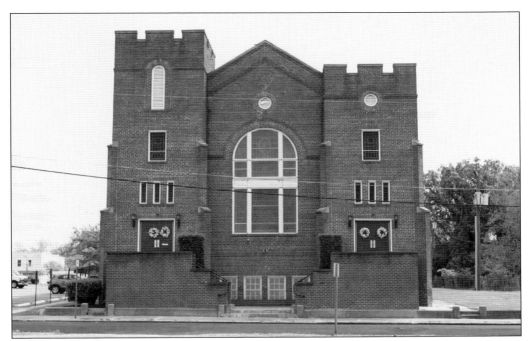

ZION BAPTIST CHURCH. On July 1, 1891, a total of 81 people from the Third Baptist Church joined together, forming the Zion Baptist Church on Byrne Street. R.G. Williams was pastor in 1959 and was a key figure in the organization of the Petersburg Improvement Association. In March 1960, he led a rally at the church attended by 1,400 people in protest of segregation. Andrew White became pastor in 1963. He was instrumental in the adoption of various low-income assistance programs. (Courtesy of L. Charboneau.)

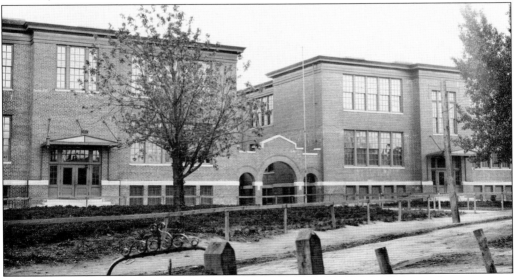

PEABODY. The oldest school for African Americans in Petersburg and one of six surviving educational facilities designed by architect Charles M. Robinson is on South Jones Street. It opened in 1920 and functioned as a high school until a new high school was built in 1950 and then served as an elementary school until 1960. (Courtesy of Jackson Davis Collection, Albert & Shirley Small Special Collections Library, University of Virginia.)

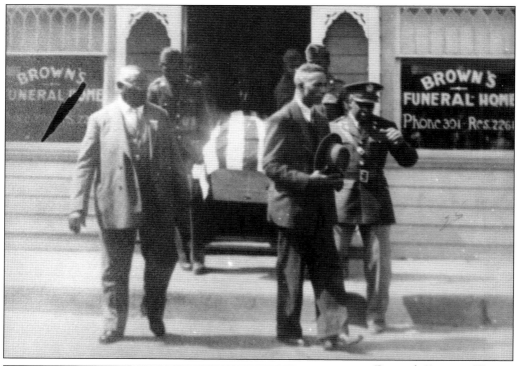

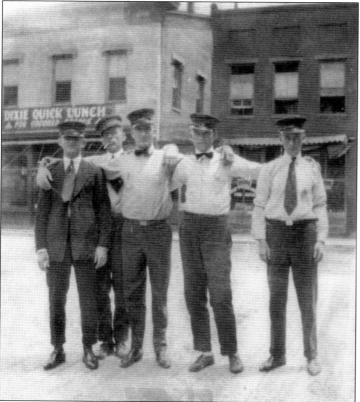

Brown's Funeral Home. Proprietor Capt. Thomas A. Brown was the oldest undertaker in two cities. In 1920, he was the sole owner of the People's Memorial Cemetery. This 1931 photograph was taken at the Petersburg location, 301 Gil Street. (Courtesy of Jackson Davis Collection, Albert & Shirley Small Special Collections Library, University of Virginia.)

Dixie Quick Lunch. Owned by J.S. Fotarides, this lunch spot was in operation at 103 Harrison Street from 1918 until 1929. These streetcar operators are pictured in front. (Courtesy of The Dixie.)

JOHNSON'S TAXI. Roscoe Johnson started Manhattan Taxi on Pocahontas in 1929. In 1931, he relocated to the Halifax Triangle, opening Johnson Cab at 103B South Avenue. In 1948, he moved to Byrne Street, where he continued to operate his cab company until his retirement in 1995. (Courtesy of Alan Sims.)

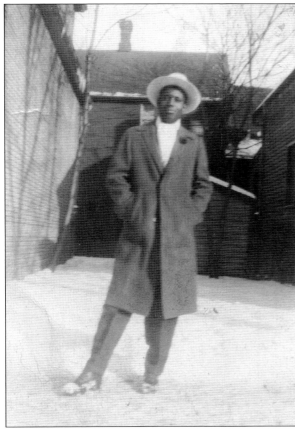

ED MITCHELL. Eddie Mitchell was a cabbie and private chauffeur. He worked for Johnson's Cab in the 1940s. (Courtesy of Alan Sims.)

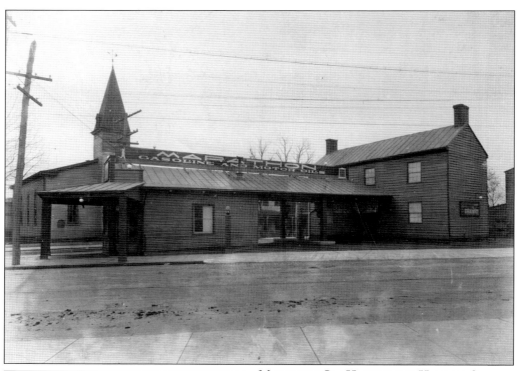

MARATHON GAS HALIFAX AND HARDING STREET, 1932. People started to make longer trips by car. Halifax Street ends in North Carolina. In the early days of automotive travel, this corner was a convenient stopping point, where one could get gas, lunch, and souvenirs. This station served the Triangle for years. (Courtesy of Delta Oil Historic Archives.)

GLORIA JONES. This photograph of little Gloria Jones was taken on Halifax Street in the 1930s. The steeple of St. Stephen's Episcopal Church is visible in the background. (Courtesy of Von Parrish.)

STAFF AT THE AMERICAN. The American Café was located at 40 Halifax Street. This faded picture from the 1940s is of the kitchen's back door and waitstaff. (Courtesy of Hattie Moore.)

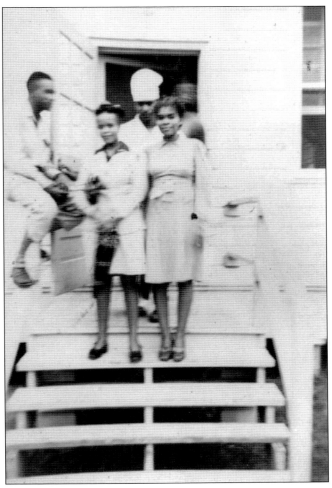

BYRNE STREET USO. This is where African American soldiers during World War II were entertained. Built in 1942, the USO offered a break from the war for both servicemen and their spouses. Closed in 1948, the building was purchased by Virginia State University. It was used by the African American businessman's organization the Beaux Twenty Club from 1960 until 2018. It is currently a community support center. (Courtesy of Alan Sims.)

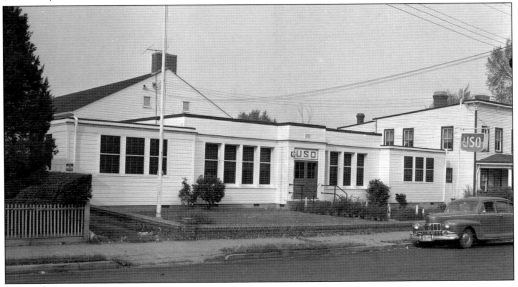

TRAILWAYS BUS DEPOT, 1985. Midcentury Americans regularly traveled by bus. This station was built in 1946 and is a rare example of both the streamlined modern architectural style and a Jim Crow–era building. It has an original block-glass curved window, neon sign, and overhang. It also has separate entrances, two waiting rooms, and two sets of restrooms. The lunchette prepared food for both races; however, African Americans could not order from or eat at the counter, and they had to use the window. During the spring and summer of 1960, multiple anti-segregation sit-ins took place here. On August 15, 1960, Trailways ended the segregation practice. The second stop of the Freedom Riders's journey in May 1961 was incident-free. (Courtesy of the Virginia Department of Historic Resources.)

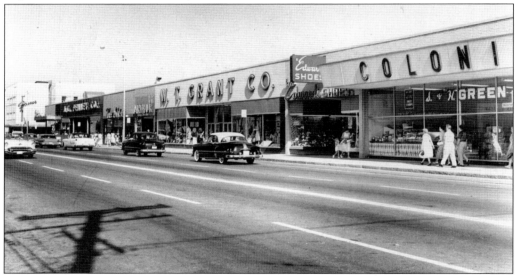

W.T. GRANT. This store, at the corner of Washington and Union Street, was a popular discount department store. For African Americans, it was okay to buy goods and get a meal to go, but they were not even to think about staying for lunch. One of multiple Petersburg lunch counter sit-ins against segregation happened at W.T. Grant. The Petersburg Improvement Association spent the spring and summer of 1960 marching in front of the store carrying signs stating, "Don't buy at Grants," and "Prejudice ecidujderp it's all nonsense to me." The Halifax Triangle & Downtown Commercial Historic District was entered in the Virginia Landmarks Register in 2017 and the National Register of Historic Places in 2019. (Courtesy of the Southern Virginia Chamber of Commerce.)

Ten
WALNUT HILL

WALNUT HILL POSTCARD. In 1862, the Petersburg city line was near current-day Apollo Avenue. On the other side of Lieutenants Run, there was Walnut Hill, owned by the Wilcox family. A small farm to the west was owned by the McKesson family. This plus land deeded by the city of Petersburg in the 1910s became Walnut Hill, a neighborhood offering new modern homes on tree-lined streets with large lots. This neighborhood has been premier for families for over 100 years. (Courtesy of R. Gold.)

YOUNG MEN OLD BOYS MONUMENT. On June 9, 1864, Union troops invaded Petersburg from the South, or current-day Crater Road. They were met by a small group of old men and young boys who tried to defend the city but were quickly defeated. This was the first battle of Petersburg, also known as the Battle of Old Men and Young Boys. From 1864 to 1865, Petersburg was a Confederate defense point. Fighting in this area was intense. What is now Walnut Hill Elementary was Confederate Fort Mahone. Where the Pine Gardens subdivision and Walnut Hill Plaza stand was Union Fort Sedgewick. A small defense battery was stationed at present-day Coggins Street. Many defensive battles were fought with men being captured and killed. (Courtesy of the Virginia Department of Historic Resources.)

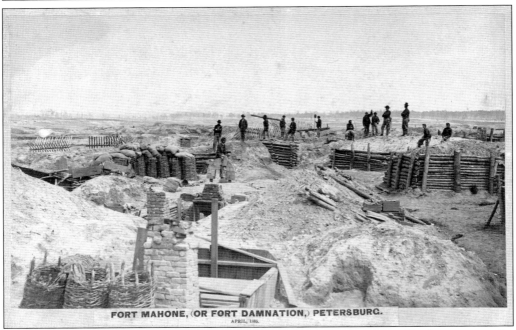

FORT MAHONE. On April 3, 1865, Pres. Abraham Lincoln was in Petersburg. His first stop was the abandoned Fort Mahone. Seeing the corpses of members of the 114th Pennsylvania Regiment, many of whom he had spoken with while visiting City Point, the president shed tears. (Library of Congress.)

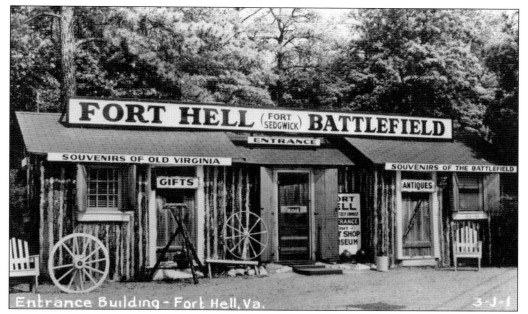

FORT HELL TOUR. Where Wakefield and Crater now meet was a tourist site that opened in 1905. Visitors were able to tour the remnants of both the Union mines of Fort Sedgewick and the Confederate Fort Mahone. The tourist trap operated under multiple names, including the Pine Garden Tunnels, Fort Hell Battlefield, and the Lyons Tunnels. It was in operation until 1968. (Courtesy of R. Gold.)

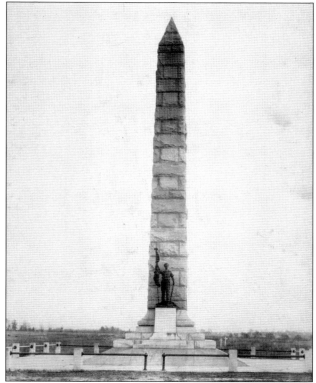

HARTRANFT MEMORIAL. There were 1,272 soldiers killed in the Battle of Fort Stedman. In 1909, the Commonwealth of Pennsylvania had the Hartranft memorial erected in their memory. Directly in front of the granite obelisk stands the Lincoln in Petersburg statue. Installed by the Virginia Civil War Trails, it commemorates President Lincoln's emotional stop at Fort Mahone. (Courtesy of Library of Virginia.)

WALNUT HILL AD. The Walnut Hill Corp was formed in 1909. A housing development was planned in 1911. The City of Petersburg deeded 39 acres to the project. Construction began on new homes with modern conveniences like electricity, indoor plumbing, and yards. The first streets are Berkeley, Brandon, North, South Sycamore, Matoax, and Westover. So desirable by 1915, unbuilt lots on South Sycamore were selling for $4,000. An addition was planned. This 1920 advertisement was for the addition, which became present-day Monticello Street, Mount Vernon Street, Blair Road, Oakland Street, Wilton Road, and West Tuckahoe Street. (Courtesy of the Petersburg City Directory.)

CHRIST AND GRACE ROCK. Christ and Grace Episcopal Church was built in 1923. On Christmas Eve of 1932, George Harrison Jr. and Holmes Boisseau Jr. disappeared while fishing in the Appomattox River. Their bodies were recovered later that year. The stone that they were pinned beneath was put in front of the church in their memory. The bell tower pictured here was built as a memorial to Ada Crass Pollard in 1973. It holds the church's original bell. (Courtesy of the Virginia Department of Historic Resources.)

1705 JOHNSON ROAD. Every architectural style can be found in Walnut Hill. This Spanish American home was built by the Totty family in 1946. They lived here until 1987. Robert A. Totty was the president of the American Hardware Company, a trunk manufacturer. (Courtesy of Dwayne Nelms.)

1662 MONTICELLO STREET. Smaller, modest homes began being built to accommodate the rapidly growing population. This home on Monticello Avenue is super cute, covered in snow at Christmas. (Courtesy of Zanna Hickey.)

PARHAM'S. Parham's has been serving the neighborhood's automotive needs since the 1950s. This station is on the corner of South Boulevard. Wynne Churn started working at Parham's in 1973 and later purchased the station. It is still operated by Wynne and his family. (Courtesy of Wynne Churn.)

WALNUT HILL FIRE STATION. By 1945, Walnut Hill had grown to be the largest neighborhood in Petersburg. Modern homes and businesses needed maximum protection. Here is the crew in 1975. (Courtesy Fire Station No. 2.)

CLAREMONT AVENUE. In the 1910s, the McKessons owned a farm that later became the Walnut Hill extension. They had a driveway lined with juniper cedar trees that extended from Crater Road to Wilton Avenue. By the 1950s, that farm had been developed into moderate-sized brick houses on large lots. The cedar tree row is clearly visible in the backyard of 405 Claremont Avenue in this photograph taken in 1953. In 2024, a few of those trees are still standing. (Courtesy of Robin Beckwith.)

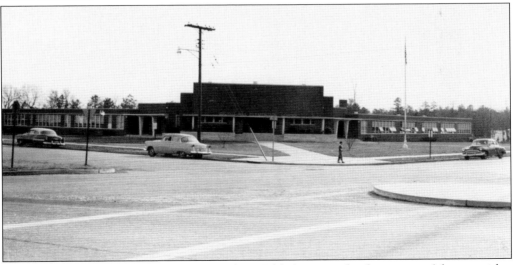

WALNUT HILL ELEMENTARY SCHOOL. Opened in 1955, this new school was state of the art, with a linear design, large classrooms, and an indoor gymnasium. (Courtesy of Library of Virginia.)

MAILMAN, 1959. Mail was delivered to one's door, as it still is. Bob Barlow's mail route was in Walnut Hill from 1948 until 1965. (Courtesy of Tony Carpenter.)

WESTOVER AVENUE. Westover Avenue is one of Walnut Hill's most impressive streets. This brick Colonial-style home at 1546 Westover is whimsically decorated for the holidays. (Courtesy of Anne Dovikan.)

SOMEWHERE IN WALNUT HILL. People walking their dogs was a regular activity in the 1940s as well. This picture of unidentified walkers could have been taken anywhere in the neighborhood. (Courtesy of Zanna Hickey.)

BOWLING CHAMP. The Fort Hell museum and gift shop were replaced by Walnut Hill Lanes Bowling Alley. Kelly Klahil of 1644 Monticello Avenue was the junior miss bowling champion in 1970 and 1971. (Courtesy of Tony Carpenter.)

OAKLAND AVENUE. Walnut Hill homeowners love a pretty yard. Betty Dodge preps her garden on the corner of Oakland and Weyanoke Streets in 1972. (Courtesy of Von Parrish.)

THE BRICK BARBECUE. In the 1950s, many home magazines had instructions on building a grill. In this 1972 photograph, Florence Montague of 1827 Oakland Street is seen sitting on the one in her backyard. (Courtesy of Von Parrish.)

MATOAX AVENUE. Vicki and her daughter Lynda walk up the sidewalk on a beautiful tree-lined street. For over 100 years, Walnut Hill has been the perfect neighborhood to raise a family. William and Vicki White's family still live in the home they purchased on Matoax Avenue in 1963. (Courtesy of Lynda White.)

BOB AND LYDIA VAN FOSSEN. Who knew that Santa lived on Burke Street? Married for 51 years, Robert and Lydia Van Fossen were the perfect representation of Mr. and Mrs. Claus for 40 years. Walnut Hill was listed on the Virginia Landmarks Register in 2022. (Courtesy of Bob Van Fossen.)

Discover Thousands of Local History Books Featuring Millions of Vintage Images

Arcadia Publishing, the leading local history publisher in the United States, is committed to making history accessible and meaningful through publishing books that celebrate and preserve the heritage of America's people and places.

Find more books like this at
www.arcadiapublishing.com

Search for your hometown history, your old stomping grounds, and even your favorite sports team.

Consistent with our mission to preserve history on a local level, this book was printed in South Carolina on American-made paper and manufactured entirely in the United States. Products carrying the accredited Forest Stewardship Council (FSC) label are printed on 100 percent FSC-certified paper.